D0372216

A LIPPER™ / PENGUIN BOOK

LEONARDO DA VINCI

Sherwin B. Nuland is the author of the bestselling *How We Die*, which won the 1994 National Book Award for Nonfiction; *The Mysteries Within: A Surgeon Reflects on Medical Myth; Doctors: The Biography of Medicine;* and *The Wisdom of the Body*, published in paperback as *How We Live*. He is Clinical Professor of Surgery at Yale University, where he also teaches medical history and bioethics. He lives in Hamden, Connecticut.

SHERWIN B. NULAND

Leonardo da Vinci

A Penguin Life

A LIPPER™/PENGUIN BOOK

PENGUIN BOOKS
Published by the Penguin Group
Penguin Group (USA) Inc., 375 Hudson Street, New York, New York 10014, U.S.A.
Penguin Group (Canada), 10 Alcorn Avenue, Toronto,
 Ontario, Canada M4V 3B2 (a division of Pearson Penguin Canada Inc.)
Penguin Books Ltd, 80 Strand, London WC2R 0RL, England
Penguin Ireland, 25 St Stephen's Green, Dublin 2, Ireland (a division of Penguin Books Ltd)
Penguin Group (Australia), 250 Camberwell Road, Camberwell,
 Victoria 3124, Australia (a division of Pearson Australia Group Pty Ltd)
Penguin Books India Pvt Ltd, 11 Community Centre,
 Panchsheel Park, New Delhi - 110 017, India
Penguin Group (NZ), cnr Airborne and Rosedale Roads, Albany,
 Auckland 1310, New Zealand (a division of Pearson New Zealand Ltd)
Penguin Books (South Africa) (Pty) Ltd, 24 Sturdee Avenue,
 Rosebank, Johannesburg 2196, South Africa

Penguin Books Ltd, Registered Offices: 80 Strand, London WC2R 0RL, England

First published in the United States of America by Viking Penguin,
a member of Penguin Putnam Inc. 2000
Published in Penguin Books 2005

10 9 8 7 6 5 4 3 2 1

THE LIBRARY OF CONGRESS HAS CATALOGED
THE HARDCOVER EDITION AS FOLLOWS:
Nuland, Sherwin B.
Leonardo da Vinci / Sherwin B. Nuland.
p. cm.—(A Penguin life)
"A Lipper / Viking book."
ISBN 0-670-89391-9 (hc.)
ISBN 0 14 30.3510 X (pbk.)
1. Leonardo, da Vinci, 1452–1519. 2. Artists—Italy—Biography.
I. Title. II. Penguin lives series.
N6923.L33 N85 2000
709'.2—dc21
[B] 00-032061

Printed in the United States of America
Set in Centaur
Designed by Francesca Belanger

To my two Italians:

Salvatore Mazza and my brother, Vittorio Ferrero

Searching for the Man

IN THE EIGHTH YEAR of my near-idolatrous fascination with the life of Leonardo da Vinci, I made a pilgrimage to the house where he was born. Or so I thought.

It was 1985, and my wife, Sarah, and I were in Florence. On our second morning in the city, without a moment's forethought, we precipitously decided to visit Vinci, where neither of us had been before.

What better place to go for directions than the Museo di Storia della Scienza? Finding it closed, I knocked on the massive wooden door, and to my surprise it was opened just a crack by a woman who heard me out and then went inside to ask the *direttore* for advice. She quickly returned with her boss, and Sarah and I soon found ourselves on the train to Empoli, a distance of about twelve kilometers. From there we took a short bus ride to Vinci. Vinci proved to be a town indistinguishable from most others in the area, except that it had a small museum where models of Leonardo-inspired machines were available for inspection. And there was something else. Large signs pointed the way to La Casa Natale di Leonardo—the great man's birth-

place—said to lie at a distance of three kilometers. What the signs did not say was that the three kilometers were entirely up a steep hill, which we now proceeded to climb. Upon having hauled ourselves up to the top, we were rewarded by the presence of a large stone building, clearly the ruin of a Renaissance house. We had arrived at the very place.

Strangely, neither Sarah nor I felt the sense of elation we had expected. The inside of the structure consisted of a single large stone-floored room with a wide hearth at one end. An elderly woman was selling souvenir postcards. There was nothing else, either physically or spiritually. Whatever we had expected to find was not there.

A few other tourists wandered aimlessly through the space, looking as disappointed as we did. I tried to counterfeit enthusiasm for Sarah's sake and she did the same for mine, but nothing availed. After all the effort to get to the natal place of my hero, the result was anticlimactic. Still, it *was* his birthplace, even if its austere old bricks seemed to have no message for us. At first, we were reluctant to leave, continuing, I suppose, to cling to the hope that one or the other of us would be seized with inspiration by just the thought of our being there. When about twenty minutes of this had no demonstrable issue, we made up our minds to leave. Hitching a ride in a German tourist's Mercedes, we made short work of getting back to the center of town. Absent the anticipation of the ascent, the ride down the long hill was depressing. It had been a

drought year in 1984—every olive tree was still barren and shriveled, the grass was brown, and the soil was parched and almost sandy. In such an atmosphere, it was difficult to conjure up the classic image of the golden-haired child Leonardo becoming ever more enthralled by the beauties of all the magnificence of living nature around him, as he gamboled in the lush beauty of the surrounding fields.

And there was worse to come. Some long time later, I came to realize through my reading and conversations with Italian friends that no one has any idea where Leonardo was born. In fact, his natal house may not even have been in Vinci. According to some, he was born in the nearby town of Anchiano and brought to Vinci only after a few years, or perhaps it was a few months. Sarah and I may have been in the house where he was born, but then again we may not. To add to the confusion, we later found out that our walk up the hill had taken us out of Vinci and into Anchiano itself, whose citizens consider the Casa Natale di Leonardo to be a hoax perpetrated on gullible tourists.

Leonardo was not to be found in that place. In fact, he is not to be found in *any* place. He is not a creature of places or monuments or even of permanence. He flashed across his time and was gone, leaving a vast body of work almost none of which except the paintings could be fully appreciated until centuries after his death, and far away from the house in which he was almost certainly not born.

Quoting the famous statement of Freud, "He was like a man who awoke too early in the darkness, while the others were all still asleep," the eminent Vincian scholar Ladislao Reti has followed the image by pointing out how many of Leonardo's manuscripts disappeared into that darkness. It is only through the relatively recent rediscovery of some of them that the enigma of his genius is being illuminated. And yet he remains, and always will, precisely what Reti calls him: the unknown Leonardo.

Leonardo da Vinci was a creature of ideas. In some ways, he is elusive; in others, he is so close to us that his voice is easily heard. Far more is known about his thought and the great range of his mind than about the actual events and circumstances of his life. But even his thought must remain always somewhat obscure to us. If he is, as Sir Kenneth Clark so appropriately calls him, "the most relentlessly curious man in history," he is also the historical figure about whom we are most relentlessly curious.

As Leonardo must ultimately remain unknown to us, so did the restraints remain to him, that perforce stood in the way of his achieving his objectives as a student of nature. Without the instruments, the mathematics, the experimental methods of a later time, he could not have known in which direction to set out so that he might achieve his final aim, which was a systematization of all knowledge of nature. So he struck out in every direction at once, and the greatest of wonders is how much he was able to achieve in

the absence of technologies and information that would be available only to modern thinkers. He has been criticized, now and in his own time, for finishing so little of what he started. And yet, how could it have been otherwise, at least in the areas of his scientific work? The probings of his mind had gone well beyond the supporting knowledge and technology of his era. Had much more been available, it would certainly have released his genius to fly as far in reality as it did in his conjectures and fantasies. Kenneth Keele, the foremost authority on Leonardo's anatomical studies, once sent me a paragraph extracted from a letter to a mutual friend, in which he described his own feelings about these matters, aroused while he was working on some of Leonardo's manuscripts:

> At every page I am fascinated by his intelligent questions and answers. But I often find myself realizing that however intelligent, however full of instinctive weight the questions are, if the supporting base of knowledge is not there the answers are bound to contain errors. This makes my tale inevitably one tinged with sadness; and the more Leonardo struggles within his chains of ignorance the sadder it becomes. Especially is this so because though he breaks his fetters in many places he never escapes from them. I wonder if in a number of fields (I would cite sociology, psychology, thanatology) we are not in a rather similarly sad state today with the fetters being no less powerful for being unknown to us, even unfelt.

Of course, it is true that just as we have no way of knowing or even estimating the fences and fetters that still restrict even such mathematics-based studies as physics and astronomy in our day—let alone the fuzzier fields of Keele's concern—Leonardo could not have known the fifteenth century's limitations to his possible accomplishments. As he saw it, there were no boundaries and no impossibilities; hard work and constant application would solve all riddles. "God sells us all good things at the price of labor," he wrote, quoting from Horace. But he (as well as Horace) was wrong, and not only because his ideas outstripped his era. Though he was a man well beyond his time, he was yet a man of his time and subject to certain deeply internalized preconceptions by which he was unknowingly led into error in some of his interpretations. As much as he denied it and tried to avoid it, he was nevertheless silently influenced by the formulations of his predecessors and restricted by the spirit of the Renaissance. As free and open as that spirit has been proclaimed to have been, it was only so in comparison to what had come before. Leonardo needed the seventeenth century, or perhaps the twentieth. It was not only the spirit of a later era that was needed, but its very knowledge and the lessening of the inherent biases of earlier times. Failing that, even this expansive reach of man's intellect must leave us with the sadness Keele felt, that it could not have been otherwise.

And yet, despite the limitations imposed by those unavoidable fetters, Leonardo's was a modern mind, the first

of its kind that posterity can look back on. Like every true scientist of every era, he was taught by nature, and determined never consciously to allow himself to be slave to the thinking of the past. That the past sometimes entered unknowingly into his interpretations of what he saw should not blind us to the detachment with which he attempted to make his observations. His writings refer only infrequently to the great men of antiquity. He fought powerfully against the unseen temptations of his intellectual heritage, and won far more often than he lost. "Anyone who in discussion relies upon authority uses not his understanding but his memory," he wrote. In the last analysis, he trusted only what he could see in his own studies. Those misinterpretations that inevitably crept into his writings were the result of an inherited tradition so pervasive that even the thinking of a genius of such magnitude could not entirely escape them.

Though he has often been called the ultimate Renaissance man, there is much to be said for the argument that Leonardo was only in part a man of the Renaissance. While he epitomized the zest for life and nature that was the guiding theme of humanism, he did at the same time eschew the dependence on ancient sources and the worshipful repetition of its principles that equally characterized its scholarship. "Those who study the ancients and not the works of Nature," he wrote, "are stepsons and not sons of Nature, the mother of all good authors." He was the first to approach the pronouncements of the Aristot-

les, Ptolemys, and Galens as teachings to be tested and challenged rather than as teachings to be necessarily accepted and verified. That his basic frame of reference originated in their writings meant only that he was, indeed, a fallible man of his time; some of his greatest errors and missed opportunities resulted from that background of classical thought which he could not escape. His astronomy was largely Ptolemaic and his physiology Galenic. But when the objectivity of his eye showed him otherwise as he came to "abundantly appreciate the infinite works of nature," he did not hesitate to say so. And this is why we find in one of his notebooks such jots as a statement astonishing for its time: "The sun does not move." As his ultimate direction was to question the heritage of earlier ages and seek only the truth of his own experience, he was able to blaze new paths through territories that his contemporaries believed to have been correctly charted long before their time.

The theme of Leonardo's science is the experimental method, an approach to the study of nature said not to have been introduced until the seventeenth century. The experimental method was the key to the so-called Scientific Revolution, for which that century is renowned. But Leonardo had already awakened in the darkness. Had he stayed abed two hundred years longer, he would have been far less fettered and the beneficiary of far more knowledge and technology than he was. Who can doubt that he might have left a heritage to rival—and probably exceed—

those of such as Kepler, Galileo, Harvey, and even Isaac Newton?

This is the Leonardo da Vinci who has fascinated me all these years, and particularly the anatomist in him. The magnificence of his artistic gifts and the splendor of his paintings are well known to the world. He lived, after all, in a time when artistic achievement was the glory of princes and populace alike. Giorgio Vasari, a generation later writing as an artist about artists, left to the world an indelible image of a Leonardo "truly admirable indeed, and divinely endowed. He might have been a scientist if he had not been so versatile. But the instability of his character caused him to take up and abandon many things." These words, in the 1568 edition of Vasari's *Lives of the Artists,* were written long before any comprehension of Leonardo's scientific accomplishments was possible. Like so many others of the time, Vasari saw him as far less productive an artist than he might have been had he not trifled with science. What was mistaken for instability was only Leonardo's itch to get back to scientific work, from which he too often felt distracted by the more practical matters of artistic productivity. There were long periods when he actually became impatient with painting. Thus, in a letter attempting to explain to an eager patroness, Isabella d'Este of Mantua, why a commissioned portrait of her was delayed, Fra Pietro di Novellara, the vicar general of the Carmelite Order, wrote to her in April 1501, "[H]is mathematical experiments have so estranged him

from painting that he cannot bear to take up the brush." Such an attitude was incomprehensible to all but a few of his colleagues and patrons. Though Vasari marveled at the anatomical studies, he believed that Leonardo's heir, Francesco Melzi, merely "treasures these drawings as relics," for that was thought to be their only value.

We know far better today. We know that although Leonardo initiated his anatomical studies in order to enhance his art, they in time became an enthusiasm unto themselves, and finally one of the major endeavors on which his genius was focused. We know, moreover, that, as in many other matters, he leaped so far ahead of his time that even *he* could not appreciate the trajectory upon which he had embarked. The medical historian Charles Singer has said of him, "[H]is anatomical notebooks . . . have revealed him for what he was: one of the greatest biological investigators of all time. In endless matters he was centuries ahead of his contemporaries." And we know something further: The more the manuscripts of Leonardo are studied, the more one begins to see him not so much as a transcendent artist, but as primarily a man of science, whose skills and commissions as an artist and engineer enabled him to support his fascination with nature.

Not only is it the anatomy of Leonardo that has obsessed me, but his elusiveness as well. Struggling to the top of a steep hill in Vinci or Anchiano and finding nothing more than a "perhaps" seems symbolic of the problem faced not only by the professional Leonardo scholars, but

by the rest of us as well, struggling to comprehend who he was. The dates, the facts, the known events are far fewer than we need if we are to understand how such a being could have existed. The enigma of the *Mona Lisa*'s smile is not less than the enigma of her creator's life force. Or perhaps that smile is in itself Leonardo's ultimate message to the ages: There is even more to me than you can ever capture; though I have spoken so intimately to you in my notebooks even as I have spoken to myself, I have kept final counsel only with the depths of my spirit and the inscrutable source that has made me possible; seek as you may, I will commune with you only so far; the rest is withheld, for it was my destiny to know things you will never know.

The Events: The Early Years, 1452–1482
Birth to Age 30

ONE DAY in the early spring of 1452, a prosperous eighty-year-old landowner set down a few details of a recent notable event in his family: "A grandson of mine was born, son of Ser Piero my son, on April 15 Saturday at three o'clock in the night. His name was Lionardo." There follow the name of the priest who baptized the little boy and a list of ten people present at the ceremony. Using today's methods of calculation, the time of birth was 10:30 P.M.

The old man, Antonio da Vinci, had been a successful notary, as had his father, grandfather, and great-grandfather before him and his son Ser Piero afterward. Accordingly, he had long been accustomed to recording the significant landmarks in his family's history. To this unwavering habit we owe one of the few indisputable facts now known about the first thirty years of the life of a man whom many have called "the greatest genius the world has ever seen." Leonardo's genius lay not only in the magnitude of his perceptions and talents; it resided also in the extraordinary range of the interests to which he applied them. He approached everything he did with the enthusiasm of an ama-

teur and the skill of a professional: painting, architecture, interior design, engineering, mathematics, astronomy, military ordnance, flight, optics, geology, botany, the diversion of rivers and the drainage of swamps, city planning—and lastly, the field on which this brief biography is primarily focused—anatomy and the functioning of the parts of the body.

We know that Lionardo—or Leonardo—was a love child, a delicate term with implications of a grand passion which in reality was more likely to have been lust than romance. His mother was a girl of the town of Vinci or a neighboring community. Almost nothing of her is known beyond her name, Caterina, and her subsequent marriage to one Accattabriga di Piero of Vinci, who is listed as her husband on the tax rolls of 1457, when they were living in Anchiano on land belonging to Ser Piero's family. As noted earlier, it was in Anchiano that some say Leonardo was born, while others say Vinci, one respected authority going so far as to insist that he knew the precise site: "a house under the south side of the cliff of the castle of Vinci, toward the east." Amidst all the inexactness, who is to say with any assurance that the great event did not take place in the ruin I visited in 1985?

Nothing is known about Caterina's relationship with her child. It is probable that she nursed him for much of the first year of his life, as would have been the custom of the time, but the only information of a definite nature is that his name appears on Antonio's tax report for 1457 as

a five-year-old living in the household and specified as "illegitimate." From this single datum, much has been made.

One of the most prominent of Leonardo scholars, Edward McCurdy, wrote in his authoritative 1928 *The Mind of Leonardo* that his subject was not only born at Anchiano, but "there he lived in the years of his childhood," implying, as have others, that the little boy remained with his biological mother until shortly before the notation on the 1457 tax register. Though this can be no more than a surmise, it is the same one that Sigmund Freud had made in his fabled (in more than one sense of the word) 1910 monograph on the relation of Leonardo's libido and presumptive homosexuality to his achievements. It is also the assumption expressed by Kenneth Keele. Others avoid the subject entirely or gingerly step around it, as did the British historian of science Ivor Hart, who, after studying his subject's life for some forty years, wrote in 1961 that "Leonardo was accepted into [Ser Piero's] family a few years after he was born."

Shortly after his illegitimate son's birth, the twenty-five-year-old Ser Piero married a woman of good family, Albiera di Giovanni Amadori, with whom he was unable to have children. It is the contention of several biographers that after some five years of frustrating childlessness, the couple brought little Leonardo to live with them in Vinci, where the kindly Albiera treated the boy as though he were her own. He would thus, for the most formative years of his personality development, have been the

adored only child of the devoted and perhaps over-loving Caterina. During those first five years, if this construction is correct, he was also essentially without a father.

Of course, there is no way of knowing whether any of this is accurate. The child may just as well have been sent off to his father's house at the time of Caterina's marriage, whenever it was. Or he may have been taken to the large house in Vinci shortly after having been weaned. The story is so filled with "may haves" that any conjecture is as valid as any other. It suited Freud's theory about the roots of homosexuality that the young Leonardo should have spent his first five years living alone with his unmarried mother. In this formulation, the boy became the sole object of the erotic attachment that a child ordinarily shares with his father, a love made more intense in this case by having only the single focus. This is how Freud explains his theory in the monograph, *Leonardo da Vinci: A Study in Psychosexuality:*

> In all our male homosexuals, there was a very intense erotic attachment to a feminine person, as a rule to the mother, which was manifest in the very first period of childhood and later entirely forgotten by the individual. This attachment was favored by too much love from the mother herself, but was also furthered by the retirement or absence of the father during the childhood period. . . . The love of the mother cannot continue to develop consciously [because it is too threatening to the child] so it merges into repression. The boy represses the love for the mother by putting himself in her place, by

identifying himself with her, and by taking his own person as a model through the similarity of which he is guided in the selection of his love object. He thus becomes homosexual; as a matter of fact, he returns to the stage of autoeroticism, for the boys whom the growing adult now loves are only substitutive persons or revivals of his own childish person, whom he loves in the same way as his mother loved him. We say that he finds his love object on the road to narcissism, for the Greek legend called a boy Narcissus to whom nothing was more pleasing than his own mirrored image, and who became transformed into a beautiful flower of this name.

Whatever other factors, biological or experiential, that may enter into the genesis of male homosexuality—and Freud acknowledges that "the process recognized by us is perhaps only one of many," among which is "the cooperation of unknown constitutional factors [now generally accepted as being genetic]"—it was long a staple of psychoanalytic theory that an over-loving mother and a nonparticipant father can be significant operative influences in the psychological evolution of at least some homosexual men. As controversial as that theory has in recent years become, it is still held to be valid among more than a few members of the psychiatric community.

Biographers who touch on the subject rarely express doubt that Leonardo was homosexual. This was the opinion famously stated by Kenneth Clark in the Ryerson Lectures, delivered at the School of Fine Arts at Yale in 1936.

Though some of Clark's reasoning smacks of the stereo-
types accepted at the time, there is otherwise much to con-
sider in his argument: "To my mind the proof of
Leonardo's homosexuality . . . is implicit in a large section
of his work, and accounts for his androgynous types and a
kind of lassitude of form which any sensitive observer can
see and interpret for himself. It also accounts for facts
which are otherwise hard to explain, his foppishness in
dress combined with his remoteness and secrecy, and the
almost total absence, in his voluminous writings, of any
mention of a woman." Clark might also have spoken of
his subject's predilection for attractive boys and young
men as pupils and retainers, a fact much remarked upon by
commentators close enough to his time to have had per-
sonal knowledge. Such evidence, is, of course, circumstan-
tial, but there is a great deal of it and little to contradict
its general interpretation.

There is no indication that Leonardo ever engaged in
overt sexual activity of any sort, whether one seeks it in his
manuscripts or in the testimony of those who have left
recollections of him. It is Freud's contention that he was
one of those rare individuals whose "libido withdraws
from the fate of the repression by being sublimated from
the outset into curiosity, and by reinforcing the powerful
investigation impulse [which would otherwise be directed
toward sexual curiosity]. . . . The investigation becomes to
some extent compulsive and substitutive of the sexual ac-
tivity. . . . The subjection to the original complexes of the

infantile sexual investigation disappears, and the impulse can freely put itself in the service of intellectual interest. To the sexual repression which made it so strong by contributing sublimated libido to it, it pays homage by avoiding all occupation with sexual themes."

This, in a few sentences, is Freud's explanation for the origins of Leonardo's genius and the extraordinary range of his accomplishments. Briefly, the repressed sexual impulse was sublimated into curiosity and intellectual investigation. The entire energy of the libido, which is meant to be focused on one or another love object, was instead focused on his work. All of us, whether hetero- or homosexual, sublimate libido to a greater or lesser extent, but for Freud's Leonardo the sublimation was total. Leonardo may have intuited the validity of that formulation. On a page of the volume of his writings that scholars have brought together as the *Codex Atlanticus*, the following is to be found: "Intellectual passion drives out sensuality."

Freud's thesis has been ridiculed, and the more unfashionable he has become in recent decades the more it is rejected. And yet, the principles of sexual repression and the sublimation of libido continue to be so generally accepted that one is hard put to understand the deep opposition that his Leonardo monograph has engendered. It is true that Freud made a huge error by misunderstanding a childhood memory that Leonardo recorded: He accepted an earlier writer's misreading of "vulture" for "hawk," and was thereby led on to a false trail of mythology that he mistak-

enly put forth as evidence for the fellatio fantasy of the child of an absent father and an over-loving mother. The actual notation by Leonardo is: "It seems to me that I was always destined to be so deeply concerned with hawks; for I recall as one of my very earliest memories that while I was in my cradle a hawk came down to me, and opened my mouth with its tail, and struck me many times with its tail between my lips." Reasoning backward from what was more probably a fantasy than a memory, and elaborating on the vulture image in ancient mythological sources, Freud erroneously found support for his construction that Leonardo had been raised precisely as he theorized.

Still, Leonardo's recollection can be understood as a fellatio fantasy, even if it does not substantiate much else in Freud's argument; and still, it is probable that Leonardo was a homosexual; and still, there is no indication that he ever functioned sexually. We are left with the formulation that Leonardo was a homosexual who repressed his sex drive by sublimating his libido into a vastness of accomplishment. If we remove the currently abused name of Freud from the equation, we arrive at a distinctly reasonable explanation for his genius. Add the sublimation to an obviously great intellect and we may be seeing the Leonardo both of embellished Freudian legend and of reality.

What is to be done with the question of Leonardo's first years, or at least with his relationship with Caterina? If one accepts, as some do despite the protests of more

"modern" commentators, the thesis that the homosexual orientation of some gay men may be related to the kind of dynamic described by Freud, it must be considered that Leonardo may very well have been one of those men. If he was, it hardly makes a difference where the child lived during his early period. Whether in Vinci or Anchiano, it is not far-fetched to assume that he experienced during that time precisely the kind of mother-son relationship—if not from Caterina then from the childless and perhaps equally adoring Albiera—and father-son nonrelationship that so many psychiatrists for so many years have believed to be instrumental in the psychic life of some homosexuals.

All of this hardly makes for a QED. As long as there are an *if, perhaps,* and *may* in such an argument—diluted even further with words like *some, reasonable,* and *probable*—we are playing with conjecture based on minimal information. Which puts the whole argument squarely in the same arena as so much of all Leonardo lore. Beginning with Vasari himself, a great deal which has been inferred and even assumed is based on far shakier historical grounds than most of us would demand before making pronouncements on almost any other figure whose life we may study. In his renowned 1869 essay on Leonardo, the esteemed English critic Walter Pater may have provided the reason why such a state of affairs has always been the case. "Leonardo's nature had a kind of spell in it," he wrote. "Fascination is always the word descriptive of him." It is this fascination, exceeding what many of us feel about any

other personage of old or today, that makes us reach out with intuition, emotion, and even a sense of enchantment, as we make leaps of conjecture in seeking to understand this most inscrutable of men. In interpreting him, we interpret ourselves, and our own hidden mysteries. He has us under a spell, and I sometimes suspect he planned it that way.

In that mood—the mood of so much of Leonardo scholarship, including the very best of it—I may perhaps be forgiven for having put forth a possibility that is no more implausible than are many of the theories to be found in the field of scholarship that is often called Vinciana. I ask only, as I believe was Freud's intention as well, that my proposal concerning the origin of my subject's homosexuality not be discarded out of hand, but considered reflectively as the following story unfolds.

Leonardo's education until the age of approximately fifteen was probably to a large extent in the hands of Donna Albiera and her mother-in-law, Monna Lucia, who was fifty-nine when he was born. Private teachers of mathematics and Latin seem to have been involved, but there is no way of ascertaining how much formal instruction the boy actually had. The fact that he never did master the classical languages may in part have been due to inadequate early teaching, but he seems not to have made any sustained efforts to learn them as he became older, even though he dabbled in Latin from time to time. His knowl-

edge of some of the authorities who had written in Greek, Latin, and Arabic apparently came from a combination of reading them in Italian translation and discussing their work with various of his learned colleagues. With respect to classical and later writings, he was, as some contemporaries called him, "an unlettered man."

There may have been certain advantages to this. As noted by the eminent historian of science George Sarton, "Thus Leonardo was mercifully spared the oppressive load of that dialectical and empty learning which had accumulated since the ruins of ancient science and made true originality more and more difficult."

Some time between his son's fifteenth and eighteenth years, Ser Piero, who had by then moved his family to a rented house in Florence while retaining the property in Vinci, is said to have shown some of his son's drawings—and perhaps a few of the sculpted objects and clay models the boy was fond of making—to one of the leading artists of the city, Andrea di Cione, called Verrocchio ("True Eye"), who was then in his mid-thirties. Verrocchio showed enthusiasm for the boy's talents, and took him on as an apprentice. This in itself was a remarkably favorable turn of events, because of the wide range of undertakings in which the master's studio was involved. Himself more a sculptor than a painter, Verrocchio was also a much-sought-after designer and craftsman of metal objects of art for religious and ornamental purposes, as well as being a maker of musical instruments. Because his own artistic

interests were so varied, free rein was given to those of his pupils. They carried out commissions in silver, marble, bronze, and wood, and crafted helmets, bells, and cannon. In such an atmosphere, a young man of Leonardo's gifts could be expected to thrive.

And thrive he did. Not only in the quality and variety of his artistic endeavors, but in certain personal characteristics as well, it soon became apparent that the Vincian apprentice was one of those who, in the words of Vasari, "proves himself to be specially endowed by the hand of God." Not only Vasari but others too have written of Leonardo's handsome appearance, his powerful body and physical grace, his ability at singing while accompanying himself on the lyre, and certain traits of personality that charmed acquaintances and strangers alike. Among them was a remarkable equanimity that would remain with him for the rest of his life, combined with a warm and pleasing disposition. Stories are told—and their consistency makes it difficult to believe that they are apocryphal—of his peregrinations through the streets of Florence, dressed in brightly colored clothes and gowns distinctly shorter than was the custom, from time to time buying a caged bird in order to set it free as though in symbolic unity with his own free spirit and his reverence for life in any form. Leonardo was a beautiful youth of striking personal qualities, who matured during his years in Florence into a man of formidable talents, a gracious temperament, and a serene air of self-confidence. And yet, there were currents

of disquiet and even fear. In one of his notebooks from this time is to be found an intriguing recollection of one of his many solitary explorations of the hills near Florence.

> [H]aving wandered for some distance among the overhanging rocks, I came to the mouth of a huge cavern, before which for a time I remained stupefied, not having been aware of its existence—my back bent to an arch, my left hand clutching my knee, while with the right I made a shade for my lowered and contracted eyebrows . . . and after remaining there for a time suddenly there were awakened within me two emotions—fear and desire—fear of the dark, threatening cavern, desire to see whether there might be any marvelous thing therein.

There is much to think about in this brief notation of an adventure that, interestingly enough, led to the discovery of a large fossil fish within the cavern, that Leonardo would not have found had his desire not overcome his fear. This was, after all, a young man entranced by the beauty of all that he saw around him, and who yet in this period of his life sketched a series of peculiar-looking and even grotesque people whom he was wont to follow through the streets of Florence, apparently attracted by the very same physiognomical strangenesses that repelled him. Pater sought the meaning of these "[l]egions of grotesques [that] sweep under his hand," and may have explained far

more than he realized in his comment that "some interfusion of the extremes of beauty and terror shaped itself, as an image that might be seen and touched, in the mind of this gracious youth, so fixed that for the rest of his life it never left him." And similarly, "What may be called the fascination of corruption penetrates in every touch its exquisitely finished beauty."

The significant thing to note about Leonardo's experience in the cave is that it resulted in a discovery, one of many that in time would convince him—centuries before the studies of such as Lyell and Darwin—that the earth and its living forms were much older than was taught by the Church, and are in a continuous state of change. The fear-desire polarity is, of course, shared to some extent by all of us, but musing on that fact leads inevitably to the consideration that in Leonardo's case the poles were outsize, of such magnitude that their interplay influenced the course of many of his most significant preoccupations. Most notable among these, I would suggest, was his study of anatomy.

The dissections that Leonardo would perform in later years took place under dreadful conditions. Not only did he have to force himself to deal with his own quite natural horror of dead bodies, but the additional problem of not having any way to preserve them during the necessarily brief period of study meant that he was working on corpses that had begun to rot even before he so much as put his knife to them. But as always, his curiosity overcame

his fear. That he was aware of such considerations is evident from a warning he would give to would-be dissectors:

> But though possessed of an interest in the subject you may perhaps be deterred by natural repugnance, or, if this does not restrain you, then perhaps by fear of passing the night hours in the company of these corpses, quartered and flayed and horrible to behold.

Considering how many commentators on Leonardo's manuscripts have pointed out that his textual comments have very much the quality of conversations with himself, perhaps this is really a statement in which he speaks to his own anxieties. But either way, it is of more than passing interest that he should overtly address the issue of disgust and fear, in language so direct that one would be hard put to find its like intermixed into the technical works of other anatomists of any period, though all have certainly felt such emotions.

The earliest of the anatomical studies were done at Florence's old hospital of Santa Maria Nuova (founded, incidentally, in 1255 by Folco Portinari, the father of Dante's Beatrice) and may have been undertaken at the instigation of Verrocchio, who was known to have stressed to his pupils the importance of studying surface musculature. By this period, the old prohibitions against opening the human body had long been relaxed, and "anatomies," as they were called, were on certain occasions being done for instructional and forensic purposes. Begun by Leonardo

only with the intent of enhancing the art, in his probing hands these dissections gradually began to take on a more investigative aspect. With the lack of contradictory evidence, he can with reasonable certainty be said to have been the first artist to dissect beyond the superficial layers of the human body. He may, in fact, have been the first person as well who attempted to depict the internal organs with anatomical accuracy. There is no medical textbook of the time or previously in which the viscera are shown in anything but a diagrammatic or even a symbolic form. Before many years, Leonardo would cease to think of painting when he dissected; he was attempting to discover the secrets of the body's structure, as a way of understanding how it works. He was studying the nature of man.

But there was much else during those Florentine years to fascinate a young artist whose insatiable curiosity was constantly finding new challenges on which to focus. More than most of his contemporaries, Leonardo soon realized that a good painter must comprehend the principles of perspective, the use of light and shade, and even the way in which the eye physiologically perceives an image. He read widely, almost certainly in translation because his Latin was unequal to the task of comprehending the original texts. He studied geometry, mechanics, the flight of birds, animal and plant biology, optics, military engineering, hydraulics, architecture—he began to see art from what might be called the scientific point of view. And the converse was also true: He was seeing science from the view-

point of an artist. Even he, a man centuries before his time, could not at first have realized what an exhilarating approach he had discovered.

Of Leonardo's artistic output during his first Florentine period, little is known for certain and no completed piece has been left. Traces do remain of the work he did while apprenticed to Verrocchio, and of the aborted studies begun during the approximately six years between the end of his training period and his departure for Milan in 1482. There seems virtually no doubt that his hand is to be found in certain of the paintings done in Verrocchio's studio, and he was commissioned sometime after the apprenticeship to do an altarpiece for the monks of the Convent of St. Donato at Scopeto. Its theme was the adoration of the Magi, but it was left unfinished and is now at the Uffizi Gallery. Abandoned at an even earlier stage was a commission from the Signoria, the Florentine legislative body, to do an altarpiece for their chapel. This work seems not even to have been started. As McCurdy points out, though much is known about the progress of Leonardo's thinking during his first period in Florence, little is available in contemporary records of what he actually did, or even of the details or style of his life.

Florence was then ruled by the Medici, a family that knew well how to retain power, including the old practice of encouraging citizens to inform on one another at the smallest hint of possible impropriety. Thus it was that Leonardo and three companions were charged in 1476

with sodomy involving seventeen-year-old Jacopo Saltarelli, well known in the city as a male prostitute. After two hearings, the charges were finally dismissed in June of that year, for insufficient evidence. What is to be made of this? And what is to be made of the coincidence that 1476 was also the year in which Ser Piero, after two childless marriages, finally became a father again (in time, there would be ten more children) with his third wife? For the first time in his twenty-four years, Leonardo was not an only child. Did a certain recklessness result from his displacement by a legitimate heir?

The answer to such a question must depend in part on one's viewpoint concerning Leonardo's guilt, which virtually all biographers doubt. This episode is the only hint of sexual activity by Leonardo, and those who have been the most painstaking students of his life assume it never happened. The charges may have resulted from malice, gossip, or thin air, but one cannot help wondering what the young men did to put themselves at risk for such calumny, even though innocent. One can also not help wondering why it was that Leonardo's apprenticeship with Verrocchio apparently ended some time during the year he was charged. The two men remained good friends, and Leonardo probably lived with his teacher for much of his remaining period, but he did so as an independent artist. Most likely this conjunction of events was mere coincidence—and yet? These are the kinds of questions that have long been thrown into the air by those who would understand an

enigmatic man who lived five centuries ago. But few of the answers yet provided have sufficient weight or substance to allow them to be caught, held in the hand and evaluated.

Even when young, Leonardo was a moralist. There is no reason to doubt his sincerity when he made certain statements suggesting that his sexual life was nonexistent, whether by unconscious repression—as Freud asserts—or conscious choice. Are the following sentences the words of a man to whom the temptations of the flesh are not temptations at all, or were they written by one fighting so hard against his sexuality that he must constantly be on guard lest it overwhelm him? There is no way to know:

> Whoso curbs not lustful desires puts himself on a level with the beasts. One can have no greater and no lesser mastery than that which one has over one's self. . . . It is easier to resist at the beginning than at the end.

Like so much else in the Leonardo legend, these sentences can be interpreted to fit any of several preconceptions, but they are nevertheless of a piece with the image of a man who, whether consciously or not, denies himself the expression of an insistent sexuality.

Among those preconceptions is that of a certain unworldliness. It has appeared to some that the only matters of real importance to Leonardo were those that furthered his art and his study of science. And to a great extent, that perception is accurate. But in order to accomplish his objectives, he needed the sponsorship and protection of

powerful patrons, and he never hesitated to do what was necessary to obtain them. Again and again throughout his adult life, he made pragmatic decisions based on the ever-changing political relationships in a land where such as the Medicis, the Sforzas, and the Borgias were in constant struggles for power and the threat of incursions by foreign rulers never waned. The first example of the da Vinci Realpolitik occurred in 1481, when Leonardo, then an independent artist of Florence, was twenty-nine.

Early that year, Leonardo sent the ruler of Milan, Ludovico Sforza, a letter that was essentially a job application. It was well known that Ludovico had two problems on his mind at this time, and his correspondent made good use of both of them. The greater of the two was the imminent danger of invasion from enemies on all sides. Milan was being threatened particularly by Venice from the east, but also by the papal armies from the south and the French from the north. The lesser problem was Ludovico's desire to find just the right sculptor to produce an equestrian statue that would honor the memory of his father, Francesco.

The most obvious characteristic of the correspondence was the near-absence of any reference to the abilities for which Leonardo was most highly qualified. In a missive of twelve paragraphs, only the last so much as mentions art. And even then, its reference appears as a single sentence that in contrast to the preceding parts of the letter sounds almost laconic, an afterthought to a long series of

forceful claims of being an experienced and highly innova-
tive military engineer and in time of peace an architect and
builder of canals and monuments: Leonardo says simply,
"I am able to execute statues in marble, bronze and clay; in
painting I can do as well as anyone else."

Leonardo might not have mentioned even this much
about his artistic accomplishments had it not been that he
needed it to introduce the sentence immediately following:
"In particular, I will undertake to execute the bronze horse
which is to preserve with immortal glory and eternal honor
the auspicious memory of the Prince your father and the
very illustrious house of Sforza." The subdued statement
about his art conveys an entirely different affect from the
rather boastful (and apparently as-yet-unsubstantiated) as-
sertion of his superiority to all others as a maker of the
implements of war, a typical example of which is: "If the
use of cannon happens to be impracticable, I can replace
them by catapults and other admirable projecting weapons
at present unknown; in short, where such is the case, I am
able to devise endless means of attack." Unlike the plans of
others, which according to Leonardo "do not differ mate-
rially from those in general use," his are instead "certain se-
crets of my own."

Leonardo had, in fact, made many sketches to support
his vaunting claims to ingenuity, although he was obvi-
ously far less experienced at their fulfillment than he
would have Ludovico think. While the first definite date in
any of his manuscripts is 1489, it is very likely that many

of the military engineering drawings that have continued to amaze modern observers were made prior to the letter to Ludovico. They were far ahead of anything available in their time, not only in design but even in concept. He had obviously studied the construction of each of his instruments of warfare exhaustively. Not only that, but he must have also studied the conditions of battle so well that he had a detailed knowledge of what was needed. It may not be overinterpreting to agree with those who claim that in these early drawings and plans are to be found the forerunners of poison gas, smoke screens, and tank warfare. Whether any of the proposed engines would have accomplished their inventor's intent will never be known, since none seems to have been built or even attempted. But they achieved the objective of the letter. Leonardo was hired, and in 1482 he moved to Milan, where he would remain for almost seventeen years, until the decline of Ludovico's fortunes once again set him off on the search for secure patronage.

Actually, there may have been another factor that weighed heavily in Ludovico's decision to bring Leonardo to Milan. The *Anonimo Gaddiano,* a contemporary collection of fragmentary biographies of Florentine artists of the period, states that during his last years in Florence, Leonardo lived with Lorenzo the Magnificent for a while, which can be assumed to be some time after 1476, when his apprenticeship with Verrocchio seems to have come to an end. The prince was so taken with the young artist's

skills that he gave him space in the garden of the piazza of San Marco, apparently to work on some pieces of ancient statuary. According to the *Anonimo*, the personal recommendation of Lorenzo was the crucial factor in Ludovico's summons, the specific catalyst being the Medici's wish to present a silver lyre to his ally. This princely intercession may have been what Leonardo was referring to in a cryptic comment written near the end of his life: "The Medici created me and destroyed me." If that means what it seems to, the 1482 move to Milan was the phase of creation, and his later sojourn in Rome would be the destruction.

The Events: Milan, 1482–1500
Age 30–48

IT WAS NOT, in fact, for Leonardo's descriptions of his engines and methods for waging war that he was called to Milan, but rather for more peaceful purposes. On arrival there, he found that his patron had changed political tactics, substituting diplomacy for warlike gestures. There would be far less need for armaments and defenses, at least for the moment. In Leonardo's own notes, he recorded that his summoning was specifically that he might create the statue of Francesco Sforza. The statement is consistent with the aims and reputation of Ludovico.

To understand Ludovico Maria Sforza, it is necessary to go back one generation to his father. Francesco, the child of peasants, was a man who had risen to become a Milanese general. By a combination of political shrewdness, military power, a pragmatic marriage to the daughter of the previous ruler, Filippo Visconti, and the help of Cosimo de' Medici of Florence, Francesco became duke of Milan in 1450, having in essence usurped the throne from its presumptive Visconti heir. When he died in 1466, his first son, a sadistic tyrant named Galeazzo, became

duke, but was assassinated ten years later, leaving his seven-year-old boy, Gian, to inherit the title. Ludovico had convinced his elder brother that, should Gian die without heir, he himself would inherit the throne. Though the boy's mother became regent, Ludovico, with characteristic deviousness, declared the sickly and not-too-bright Gian fit to ascend to the dukedom upon turning twelve, thereby abolishing the regency and taking over the rule of Milan in his inept nephew's name. The only surprise in the outcome of this story is that Gian continued to live for some years. His sudden and unexplained death did not take place until 1494, whereupon Il Moro—the Moor, as the swarthy Ludovico was commonly called—ascended to the dukedom, a position he had held de facto since 1482.

In those turbulent times when noble lines lasted only a few generations, families sought to memorialize themselves as soon after ascending to power as was possible. Many of the great cultural advances that were taking place during that turbulent period occurred at the instigation, and with the aid of the open purses, of royals and the nobility, and the great mercantile entrepreneurs did the same. For the famed Italian families, the obvious route to eternal glory was to utilize the skills of the abundance of talented artists and thinkers who figuratively swarmed over their land. Political despots though they were, the Sforzas in Milan, the Medicis in Florence, and the Borgias in Rome nevertheless nurtured an atmosphere in which literature, the fine arts, and philosophy were given free rein and flourished, to the

benefit of countless succeeding generations. Francesco had begun the process for the Sforzas by building a hospital and calling to his court all manner of scholars. But in patronage of the arts, his son Il Moro exceeded him by far. Although his actual accomplishments were less than those of Lorenzo the Magnificent, Il Moro had much the same intent for Milan as his Medici contemporary did for Florence and a series of Borgias did for Rome.

Ludovico surrounded himself with artists and men of letters. As Bernardo Bellincioni, the court poet, wrote, "Of artists his court is full . . . here like the bee to honey comes every man of learning." Although the immediate motive for Leonardo's summoning was the design and creation of the statue, Ludovico had much more in mind for him, his reputation having long preceded the letter. It is known from contemporary sources that Leonardo had by this time achieved wide recognition as an artist, in spite of the fact that very little of his work was actually completed. He had won much praise for his *Annunciation, Saint Jerome,* and the *Adoration of the Magi,* the last two unfinished. He was already becoming known as a man who, in Vasari's words, "began many things that he never completed," but in spite of this was recognized as such a uniquely talented individual that his very presence would enhance the grandeur of any court that it might grace, and attract other men of accomplishment.

So, in bringing Leonardo to Milan, Ludovico was enriching his court with the presence of a young artist of wide recognition, including that of the outstanding

princely patron of men of talent, Lorenzo. Though Leonardo's first obligation was the statue, it was clear that his skills were to be employed in all manner of endeavors, among which military engineering appears to have receded into the background.

Not only the *Anonimo*, but Vasari too, emphasized the role of the lyre (though he uses the term *lute*) in Leonardo's move to the court of Il Moro, and in so doing he supports what others have written about yet one more of the Vincian's talents:

> When Ludovico Sforza became duke of Milan in 1494, he invited Leonardo most ceremoniously to come and play the lute before him. Leonardo took an instrument he had himself constructed of silver in the shape of a horse's head, a form calculated to render the tone louder and more sonorous. Leonardo was one of the best *improvisatori* in verse of his time. He surpassed all the musicians who had assembled to perform and so charmed the duke by his varied gifts that the nobleman delighted beyond measure in his society.

(It should not go unnoticed that Vasari erroneously dates his subject's arrival in Milan as approximately the year when Il Moro formally became duke, the sort of inconsistency that has plagued Leonardo studies throughout the centuries. Since only a bare outline of Vincian biographical information is available—and much of that from sources of questionable reliability—the criteria for accepting in-

formation are sometimes shaky. In reviewing the works of the virtual cavalcade of those who have written the annals of Vinciana, one can only seek to discern coherent patterns, and extract the nuggets that may lead to truth.)

It seems probable that by far the principal reason for the duke's wish to have the artist in Milan was indeed for the purposes of the statue. Leonardo had long been interested in the anatomy of the horse, and seems to have been doing dissections of the animal for years before his departure from Florence. Though many of his sketches of horses still exist, he never succeeded in completing the Sforza statue. That, or an approximation of it, had to wait some five hundred years, when the efforts of latter-day American da Vinci enthusiasts resulted, in 1999, in the bronze casting of a horse somewhat as its designer may have visualized it.*

*This proved to be an accomplishment more in the nature of an interpretation of Leonardo's intent—minus a mounted Sforza—than a consummation, since no models or sketches of the desired finished product still exist. I may not have succeeded in the pilgrimage to my hero's birthplace, but I did see that horse, displayed at the foundry in Beacon, New York, where it had been cast in sixty separate pieces in contrast to Leonardo's plan to pour it all at once through a "one and only spout." My visit occurred a few days before its emigration to the home in Milan that awaited it with the ambivalence reserved for misplaced Yankee good intentions. The riderless steed now resides far from the city's center in a large plaza that is part of the Hippodrome, Milan's race track. Alone and without esteem, it stands unvisited by tourists and ignored by the locals. To the Milanese, it is just another of the Leonardian hoaxes, a little like La Casa Natale.

The story of the failed horse (the fifteenth-century one, that is) is also the epitomizing story of both Leonardo's personality and the turbulent political climate of the era. As in so many other matters, Leonardo's approach to the construction of the statue was to work in bursts of enthusiasm that came and went amid his other bursts of enthusiasm. There were so many delays that Pietro Alemanni, Florence's ambassador in Milan, in desperation wrote to Lorenzo in July 1489, asking that one or two "masters who are used to such work" be sent because he had but little confidence that Leonardo would complete the commission. It cannot be ascertained whether these men were to take over from Leonardo or merely to cast the bronze according to his specifications, but it was not long before the master began another flurry of activity on the project. Perhaps Ludovico's wish had been merely to prod his irresolute artist into just such action. A sentence on the cover of a notebook devoted largely to Leonardo's optics reads "On the 23 of April 1490, I began this book and made a fresh start with the horse." But there must have been still further delays, because the great moment did not come until November 1493. At the lavish festivities marking the departure of Gian's sister, Bianca Maria Sforza, to be the bride of the Hapsburg Emperor Maximilian in 1493, the twenty-six-foot clay model was displayed in the courtyard of the Sforza castle, to the immense pleasure of the vast numbers of people who came to see it.

The long delays were forgiven. One of the court poets, Baldassare Taccone, wrote exclamatory verses to celebrate the huge horse of clay, and its maker: "Only look how beautiful is the horse! Leonardo alone has made it. Sculptor, fine painter, fine mathematician, so great an intellect rarely does Heaven bestow."

But the project never went any further. In November 1494, the bronze that was to have been used for the casting of the statue, some twenty thousand pounds of it, was instead sent by Ludovico to Ferrara to be made into cannon. Leonardo continued to work on his plans, but he knew the project was doomed. At one point he wrote to the duke, "Of the horse I say nothing because I know times are bad." This letter exists today only in fragments, in other parts of which Leonardo writes of his difficult financial situation, owing to not receiving his salary and yet having to pay and maintain his assistants. Ludovico's bank balance seems not to have been in much better shape than his subject's, for in 1499, when his political situation was at its worst, he gave Leonardo a large vineyard on the outskirts of Milan, meaning in that way to settle accounts. But even this was granted only after he was petitioned by his frustrated creditor. In 1500, when the city was occupied by the French troops of King Louis XII, Gascon archers used the clay horse for target practice and destroyed much of it. Eventually, it simply decomposed.

SHERWIN B. NULAND

Leonardo's six or seven years as an independent artist in Florence had not left him a man of means. Far from it. Not only were fees rather niggardly, but his practice of leaving commissions unfulfilled was not a purse-friendly habit. It is fair to say that he arrived in Milan quite broke. Though Ludovico promised generous payment, he was not always as good as his word. Sometimes weeks and months would pass without money being sent, and Leonardo would complain. Beginning during the last years in Florence, moreover, the artist had become head of a household in which students, retainers, and several friends lived together, and his expenses for the needs of daily living were often beyond his means. Add to this his oft remarked-upon penchant for living beyond his income—with horses, carriages, servants, and all the panoply of luxury—and the sum is a man frequently in arrears or at least struggling to maintain himself. Still, he somehow managed to put aside a florin here and there, as we shall see. Or it may be that his penury was not quite as bad as he made it out to be. Perhaps he thought that the only way to squeeze any cash out of a reluctant sovereign was to cry poor, which was doubtless true even if the stratagem did not always work. In the previously noted letter to the duke, complaining of not having received any payment for two years, he wrote of having to take outside commissions in order to pay the expenses of his household.

In addition to the salary that he often had to wait for even when it was eventually paid, Leonardo was free to ac-

cept commissions from others than the Duke. They were usually portraits and studies, and might have been a fine source of income had the artist been more assiduous in fulfilling his obligations. But that was not the case. Even with a reputation for unpredictability, however, his greater reputation as an artist assured that wealthy families and others would come to him in the hope that he might complete the undertakings he either promised or started. He was constantly busy; the Milan years were a period of intense activity.

From the first, Ludovico assigned work that Leonardo could not have helped but resent as distracting him from his ever-increasing fascination with scientific studies. While in Florence, he had been much involved with the frequent pageantry and revels of the thriving Renaissance city. His athleticism, graceful form, and powerful physique had enabled him to be a highly skilled and enthusiastic participant in the various games that were part of the festivities. Verrocchio was often chosen to be Lorenzo's pageant master, in which he was joyfully aided by his apprentice Leonardo. Together they designed costumes and constructed the structures borne in the colorful processions that wound through the streets in celebration of all manner of ecclesiastical and secular events.

Like Florence, Milan too was an exciting and prosperous city, much given to pageantry and tournaments. Made wealthy by its woolen industry and the manufacture of armaments, it was at that time on the verge of developing a

lucrative business in the spinning and weaving of silk. More than a hundred workshops were busy with the crafting of armor and hand weapons such as swords, lances, pikes, and halberds, to the point where the entire center of the city had about it an air of the military. Its community of some three hundred thousand people was protected by fifteen heavily fortified towers interspersed along the formidable city wall, through which entry was gained by seven massive gates. Surrounded by moats and high walls, the duke's castle stood like a threatening sentry just inside one of these gates, seemingly impervious to attack.

Not unexpectedly, Ludovico often called upon his new artist in residence to be a kind of impresario of the pageants. Leonardo seems to have been not only a designer and artist but sometimes a master of ceremonies as well. At age thirty and beyond, and with many other undertakings on his mind, he must have found the work increasingly irksome despite his previous enjoyment of it, but he had no choice. He applied all of his intensity to these functions, and his vigorous imagination too. A description of one of the extravaganzas he created, the Festival of Paradise, illustrates the grandness of his concepts. The festival was one of those ordered by Ludovico to foster the fantasy of Gian and his wife, Isabella of Aragon, that they were the real rulers of Milan. The court poet Bernardo Bellincioni wrote:

And it is called Paradise because it was made, with the great ingenuity and art of Master Leonardo da Vinci the

Florentine, Paradise, with all the seven planets which turned; and the planets were represented by men who looked and were dressed like poets, and each of these planets spoke in praise of the Duchess Isabella.

Even in those first Milanese years, Leonardo devoted his time to the study of mathematics, mechanics, or optics whenever he could. Determined to improve his vocabulary and command of language, he laboriously made his way through lists of thousands of Italian words and synonyms. No moment was wasted. It was as though he lived every day by his own dictum: "As iron rusts when not used, and water gets foul from standing or turns to ice when exposed to cold, so the intellect degenerates without exercise."

Leonardo indulged himself in his fascination with the flight of birds, and wondered about the possibility of the flight of man. He did more than wonder, drawing sketches for models of flying machines and calculating the mechanical forces that would have to be considered. In a list he drew up of the books he owned just before leaving Milan in 1499 is to be found a wide variety of texts in literature, history, science, and philosophy, with only two related even remotely to health. There are no anatomy books.

From time to time Leonardo was able to dissect a corpse (perhaps at the Ospedale del Brolo, a unit of the Ospedale Maggiore that was licensed to allow dissection), and it appears from his notebooks that he took away specimens to examine and sketch at his leisure. His anatomical

investigations had begun in Florence, but it was in Milan that they went far beyond what was required for painting, becoming more precise and even somewhat systematic. He was turning far more toward scientific studies of the body. In the words of Sigmund Freud, "The artist had once taken into his service the investigator to assist him; now the servant was stronger and suppressed his master."

Even in this, there is disagreement. In their highly regarded 1952 text, *Leonardo da Vinci on the Human Body*, Charles O'Malley and J. B. de C. M. Saunders express doubt that their subject had access to the Ospedale Maggiore, interpreting certain errors in these early drawings—corrected in the illustrations of later years—as indications that his knowledge of anatomy during this time was derived from observation, animal dissection, and reading, rather than personal dissection of humans. O'Malley and Saunders do point out, however, that by the end of the Milanese period Leonardo had introduced his innovation of cross-sectional representation of limbs, and his additional contribution of drawing structures from different angles, "as if the viewer were able to walk completely around it and observe it from every aspect," an extremely valuable resource for anatomists and particularly surgeons. Leonardo would describe his approach this way:

> The true knowledge of the form of any body will be from views of it from different aspects. And so to give knowledge of the true form of any member of man . . .

I shall observe this rule, making of each member four representations from the four sides. And in the case of the bones I shall make five, cutting them through the middle and showing the cavity of each of them.

Leonardo would continue to use this technique, which he originated, throughout his later studies. Whether or not O'Malley and Saunders are correct, what is certain is that by 1489, seven years after Leonardo's arrival in Milan, the studies had been going so well that he was able to write of his intention to publish a treatise on anatomy. He was filling his notebooks not only with his scholarly findings but with his philosophies of life too.

Leonardo was intrigued by motion, and the forces involved. The continuous flowings of energies in nature and in the life of man are a constant and even a central theme running through his manuscripts like the streamings of waters to which he so often alluded. Moving water, in fact, is his symbol for those flowing energies; it is vital to his conception of the universe. To him, the study of structure was only the beginning of the study of function and the mechanical forces that made it possible. He developed further a notion he had long held, about the pictorial and scientific capture of a single instant wherein the whole of an event or person is elucidated. Both in art and in science, he argued, one should arrest that instant and examine it, because it holds within itself the past and the future, just as it is a thing of the veriest present. In this regard, Kenneth

Clark refers to Leonardo's "superhuman quickness of eye," that enabled the flawless registering of an instantaneous impression on the brain. The art historian Sydney Freedberg has said of the *Mona Lisa* that it is "an image in which a breathing instant and a composure for all time are held in suspension."

Much taken with the motion of water as a representative of and sometimes a metaphor for the vital forces of life and the rhythmic harmony and unity of nature, Leonardo wrote, "In rivers, the water that you touch is the last of what has passed, and the first of that which comes. So with time present." There is no better metaphoric or real statement to be found in all of his manuscripts, of Leonardo's underlying thesis of the elucidation of natural events and the life of a man, as it may be discovered within an instant of time. When one adds to it Leonardo's counsel that a painter has two objects to paint, man and the intention of his soul, an entire theory of art has been encapsulated into a few sentences.

In painting, he advised, this philosophy takes the form of scrupulous attention paid to the movement of the facial muscles, most particularly those around the mouth. But all parts of the body must be minutely observed, including the trunk and the limbs, for in the attitude and posture of those structures much is to be told. Outward actions reveal inner thought; it is in the mind that movement originates. Every painting of a person is therefore a psychological study. These teachings would later be exem-

plified in the *Mona Lisa*, but during the Milan period their apogee was reached with the painting of *The Last Supper*, commissioned by Ludovico and the Dominican friars for the refectory wall of the Church of Santa Maria della Grazie.

The painting's instant is one of the most momentous in Christian scripture. As quietly as they may have been spoken, the prophetic words, "Verily I say unto you that one of you shall betray me" have just exploded on the apostles like a sudden clap of thunder. The dramatic intensity of this moment tells more than many feet of motion picture film ever could. Each of the men at the table reveals himself in an instantaneous psychological portrait that seems to betray his thoughts and even those thoughts that will come later. Though they share the response of surprise, each responds to his own surprise in a way that is his alone. As Leonardo wrote, "That figure is most praiseworthy which, by its actions, expresses the passions of the soul." We know every one of these individuals though we have never seen any of them before. No matter how vast and repeated a reading of scripture has preceded the seeing of this great painting, every apostle will henceforth live in the viewer's senses in a way previously unimagined. Is it any wonder that Kenneth Clark calls *The Last Supper* "the keystone of European art"?

The painting was probably begun in 1495 and completed by the end of 1498, during the time that Leonardo continued to work on the horse and all of those other

projects of his own that consumed so many of his hours. As one considers his methods, there seems gradually to emerge the image of a man one of whose greatest attributes was his ability to focus all of his intensity on the job immediately in front of him, regardless of whether he might later abandon it. So it seems from a brief passage written by the fifteenth-century writer Matteo Bandello:

> Many a time I have seen Leonardo go early in the morning to work on the platform before the Last Supper; and there he would stay from sunrise till darkness, never laying down the brush, but continuing to paint without eating or drinking. Then three or four days would pass without his touching the work, yet each day he would spend several hours examining it and criticizing the figures to himself. I have also seen him, when the fancy took him, leave the Corte Vecchia when he was at work on the stupendous horse of clay, and go straight to the Grazie. There, climbing on the platform, he would take a brush and give a few touches to one of the figures: and then suddenly he would leave and go elsewhere.

This irregularity of working habits, though characteristic of Leonardo, would prove the doom of the great painting. In creating a fresco, the part of the surface being painted must be completed on the same day that it is prepared, since the technique employs water-based color on wet plaster. To obviate this necessity, Leonardo used dry plaster and an oil and varnish medium that proved unable

to resist damp and the ravages of the years. By the second decade of the sixteenth century, damage had already begun to appear, which had worsened by the time Vasari saw the painting in 1556. Nine failed attempts at restoration were carried out over the centuries, which succeeded only in detracting from the master's masterpiece. When I stood in the refectory in 1995, it was only by dint of having known what to look for that I was able to discern the magnificence of what Leonardo had done. Since then, a team of highly skilled restorers has completed a twenty-year project, bringing much back to life of an essence that had been thought irretrievably lost.

Where did Leonardo take himself, when "he would leave and go elsewhere"? We have the word of a friar named Sabba di Castiglione, who watched the construction and finally the destruction of the horse, that "when he ought to have attended to painting in which no doubt he would have proved a new Appelles [a fourth-century B.C.E. Greek artist, considered the greatest painter of antiquity], he gave himself entirely to geometry, architecture and anatomy." Of course, there were also the various commissions to work on, the most significant of which was one shared with the painter Ambrogio de Predis, to create an altarpiece for the Fraternity of the Immaculate Conception. Leonardo was to paint the central panel and Predis the altar wings. As the magnificent *Virgin of the Rocks*, two versions of Leonardo's painting are now in existence, one—probably the earlier—in the Louvre and the other

in the National Gallery in London. This work was done between 1483 and 1490, amid constant haggling between the artists and the fraternity about fees and other contractual obligations. Such unpleasant disputes, as frequent as they were in the careers of most Renaissance artists, were more common for Leonardo because of his reputation for abandoning projects to which sponsors had committed themselves, or at least delaying them for long periods of time. The *Virgin of the Rocks* was a case in point. It was to have been displayed on the Feast of the Immaculate Conception on December 8, 1483, but it was not completed until 1486. Hence the prolonged quarrel over payment.

In the aftermath of a devastating outbreak of plague in 1484–85, which is said to have taken the lives of fifty thousand people, Leonardo donned his hat as a city planner, devoting considerable time to a design for the rebuilding of Milan on the basis of his studies of what was then known of sanitary and public health measures. And he far exceeded the understanding of the time. His plans called for a double system of wide roads, the upper level being for pedestrians and the lower for vehicles, each level to be flanked by arcades and connected to the other by staircases. A system of streets and canals was so arranged that goods could be delivered by boat to the shops and other buildings at the lower level of arcades.

The new city was to be built near the sea or a large river such as the nearby Ticino, a waterway known not to be muddied by the rains. In addition to providing a reli-

able source of unpolluted water, the river would also serve as a source to feed irrigation systems designed for the plains of Lombardy. The population was to be equally divided into ten townships along the river, of thirty thousand people each, in order, Leonardo wrote in his notes, "To distribute the masses of humanity, who live crowded together like herds of goats, filling the air with stench and spreading the seeds of plague and death." To Leonardo, as to urban planners of later centuries, a city should be the reflection of the values of its people, a social entity in itself. A city whose unplanned and undirected growth has led to conditions no longer symbolic of the highest aims of its leaders and citizenry is a city that must be razed and rebuilt until its structural form is the physical expression of its most elevated aspirations.

As praiseworthy as the project was, Ludovico never implemented any part of it. Had he done so it might have served as a model for the reconstruction of other European cities, many of which were just as congested and foul as were certain sections of Milan. The cost would have been enormous, and those tempestuous times were hardly propitious for such an undertaking, even had Ludovico cared enough about the lowest class of his subjects to consider an undertaking one of whose most significant benefits would be to transform their way of living. Leonardo had envisioned a city based on principles of sanitation and public health that would not be appreciated for centuries.

All during the Milan period, Leonardo was engaged in architectural projects. The most important of these was the completion of the city's great cathedral, on which he worked between 1487 and 1490. He had a wooden model built for the design of the Duomo, but later lost interest in the project, and nothing more is recorded of his participation in it. In connection with this enterprise, though, he made a series of visits to the ducal library at Pavia and to the city's university. He also did the anatomical studies at the medical school, of both human cadavers and animals. (Again, if O'Malley and Saunders are correct, the human dissections were observed rather than done by him.) His notebooks from this period contain descriptions and drawings of the human brain and cranial nerves, as well as records of experiments he made on the spinal cords of frogs.

The chair of mathematics at the University of Pavia was held at this time by Fazio Cardan, the father of Jerome Cardan, destined to become a renowned mathematician and physician whose works even today are of great historical interest. Fazio had edited John Peckham's *Perspectiva communis,* a major treatise on optics, which Leonardo had the opportunity on many occasions to study and discuss with him. It was through these readings and the long talks with Cardan that Leonardo expanded his thinking about perspective, mathematics, and the function of the eye. The eye was of particular importance to him, not only as an object of study in itself, but because it was

the means by which all visible phenomena are brought into the mind. "The eye," he wrote, "which is called the window of the soul, is the principal means by which the central sense can most completely and abundantly appreciate the infinite works of nature." It should not go unnoticed that he referred not, as virtually every other man of his time would have, to "the infinite works of God," but to those of nature. That which was of God, he left to the clergy; that which was of nature, he took to be in his domain. It was a statement worthy of a twenty-first-century researcher.

For Leonardo, mathematics was the ultimate key to the understanding of the nature he scrutinized so carefully— the key not only to mechanics and movement, but to all of science, including the biology of man. As he admonished any who would study natural phenomena, "Oh, students, study mathematics and do not build without foundations." More than a century would pass before there was general acknowledgment of the truth he wrote about his convictions: "No human investigation can be termed true knowledge if it does not proceed to mathematical demonstration."

Fazio's illegitimate son, Jerome, the great mathematician who became professor of medicine at Pavia in 1547, was a man interested, as had been Leonardo, in the application of mathematical principles to natural phenomena. In a chapter devoted to art in his magnum opus of 1551, *De subilitate rerum,* he echoed Leonardo's own certainty that

painting is the highest and most demanding form of art. But for the final sentence, the following passage might have been written by his father's departed friend. It is in the last sentence, in fact, that Cardan points out that Leonardo was the first of the artists to recognize all of the qualities required to be a great painter, and to combine them in himself:

> Painting is the most subtle of all mechanical arts, and the most noble. Painting creates more admirable things than poetry or sculpture; the painter adds shadows and colors and joins to these a speculative discipline. It is necessary for the painter to have a knowledge of everything because everything is of interest to him. The painter is a scientific philosopher, an architect, and a skilled dissector. The excellence of his representation of all the parts of the human body depends on this. This was begun some time ago by Leonardo da Vinci, the Florentine, and all but perfected by him.

As important as Fazio Cardan's friendship was to Leonardo's intellectual development, Luca Pacioli, the most distinguished mathematician of the time, would have an even greater influence, and over a longer period of time. Pacioli, a member of the Franciscan Order, was held in high esteem as a lecturer in several of the Italian universities. His highly regarded *Summa de aritmetica, geometria, proportioni et proportionalita* was already well known to Leonardo

when Ludovico invited the mathematician to Milan in 1496, two years after its publication. The two became close friends soon after Pacioli's arrival, and before long were living together in Leonardo's ménage. They were of great assistance to each other on the calculations and research involved in their respective kinds of work, and Pacioli became a kind of advanced mathematics tutor to his friend, teaching him to work with numerical roots and contributing to his studies of geometry. The relationship with Pacioli was particularly valuable to an artist so intrigued by proportion and perspective. Pacioli's next treatise, *De divina proportione*, contains sixty figures drawn by Leonardo, including his famous illustration of the proportions of the body. To accomplish this, he used the classic form introduced by the Roman architect Vitruvius, who believed that perfect proportion in a building must be based on perfect proportion in man, depicted by Leonardo with extremities outstretched, within both a square and a circle. Very likely, his contribution to this book stimulated him to his own later work on human proportion.

It was Pacioli who in a letter to Ludovico in 1498 wrote, "Leonardo with all his diligence has finished his praiseworthy Book on Painting and Human Motion," making it appear as though there was some completed volume of this name. What he meant by this is not clear, although others would later extract pages from Leonardo's notebooks and compile them into a monograph that was

given the title *Treatise on Painting*. Because it was published under that name in 1651, many people have erroneously thought it to be an actual completed book by the master.

Had Ludovico been wiser in politics, luckier in his alliances, or more skilled in war, Leonardo might have remained in Milan for the rest of his life. But Il Moro was none of these. Especially in his relations with France, he seems to have been a hapless politician, diplomat, and warrior, all at once. Having been supported by the unifier of France, Louis XI, in his intrigues for the dukedom, he found himself allied upon Louis's death in 1483 with his inept young son and successor, Charles VIII. Since Charles was ambitious to acquire the throne of Naples (which he did indeed take in 1493), one of Milan's traditional enemies, it seemed appropriate for Ludovico to invite him to bring his army to Milan for what was to be a ceremonial visit. Resentment on the part of the Milanese and bad behavior by the French soldiery resulted in considerable tension, and here Ludovico made his first grievous mistake. The pope and the Republic of Venice having formed a league against the French, he broke his alliance with Charles and joined them, along with Austria. The league succeeded in driving Charles back into France, where he died in 1498. He was succeeded by Louis XII, a grandson of the very Visconti family from whom Francesco Sforza had usurped the throne. Not surprisingly, Louis proclaimed his right to rule Milan, and not surprisingly either, the Venetians and the pope abandoned their awkward

alliance with Ludovico and joined the French king in attacking his duchy. Il Moro never so much as tested the strength of the great fortifications around his seemingly impregnable city. Seeing the French handwriting figuratively on the massive walls, he fled to Innsbruck to seek the protection of his niece's husband, the Emperor Maximilian I. In the summer of 1499, Louis rode unopposed into Milan at the head of a huge army. Among his soldiers were the Gascon archers who destroyed the clay model of the great horse.

Leonardo saw the same handwriting. Despite his frequent grumblings about payment, he had somehow managed to save up 600 florins (some say that he had recently been paid certain arrears), and this he sent in December 1499 to a bank in Florence, in preparation for taking his leave of the city that had been his home for so many years. With Pacioli, a favorite pupil named Andrea Salai, and several other friends and retainers, he left for Mantua, from which safe haven he planned to tarry long enough to observe the turns of events in Milan. Staying in that city only a short time, he traveled on to Venice, finally returning to Florence in April 1500 when he realized that his Milanese patron's efforts to retrieve the throne were to be in vain. Leonardo had just passed his forty-eighth birthday.

Meanwhile, with Maximilian's help, Ludovico had regained possession of Milan in February 1500, but in April the Swiss mercenaries in his army deserted when

confronted by a powerful French force near Novarra. Disguised as a Swiss pikeman, Ludovico was captured while trying to escape. He was taken to France, where he was thrown into a dungeon in the castle at Loches, in Touraine. There he remained until his death in 1508.

The sadness and the "might have been" of these difficult days are reflected in Leonardo's melancholy comment, probably made as he prepared to leave Venice realizing that he would not be returning to Milan: "The Governor has been made prisoner, the Viscount carried off, and his son killed; the Duke has lost his state and his possessions and his liberty, and none of his works has been finished by him." The brief glory of the Sforzas was over. But Leonardo must have had some thought of a future in that city where he had accomplished so much and left so much uncompleted, because he did not sell his vineyard, choosing instead to rent it out.

The approximate date of Leonardo's arrival in Florence is known from the bank's record that he withdrew his 600 florins in April 24, 1500. His return was to a city very different from the one he had left eighteen years earlier.

The Events: Florence, 1500–1502
Rome, 1502–1503
Florence, 1503–1506
Age 48–54

FLORENCE MUST HAVE SEEMED strange indeed to Leonardo. The Medici having been exiled a few years after his departure, the French army of Charles VIII had occupied the city. To regain some measure of independence, the Florentines had strained their resources by paying a huge bribe to Charles in order to convince him to leave, as a result of which credit and the economy were suffering. In spite of being paid off, France remained a threat, as did the armies of Pope Alexander VI. Another threat, although less overt at that moment, was the surviving head of the Medici family, Piero, plotting his return to power. As if all of this were not enough, the Pisans were in revolt. Though now a republic, the great city of Florence was permeated with the portentous air of unrest.

At forty-eight, Leonardo was entering a period of his life that was considered old age, not so much on account of the average life expectancy being in the late thirties but because the waning of powers set in a lot earlier than it does today. He was no longer the promising young artist beginning to

be known as a man with a brilliant future. In spite of their ultimate failure, the Sforza horse and the *The Last Supper* had made him famous throughout Italy and probably all over Europe, as had some of the other work he had done in Milan. Awareness of his involvement in scientific and mathematical studies—though few knew their details—magnified his reputation for genius. Leonardo's return was a source of optimism in Florence, and despite his chronological age he remained a man of great vigor and enthusiasm. Much was expected of him. But the general pleasure at Leonardo's presence was apparently not shared by a moody twenty-five-year-old esthete named Michelangelo Buonarroti, then emerging as the most talented young artist in the city.

Leonardo was in certain ways different from what he had been during his previous sojourn in Florence, in the sense that the qualities so impressive in his youth had evolved into the maturity of great accomplishment, despite so much having been left uncompleted or even unattempted. His reputation as a military engineer was extraordinary, albeit that Ludovico had implemented virtually nothing of his suggestions; he was considered a great architect though there was little to show for it; his supervision and design of civic festivities was known far and wide (but he was by then fed up with it); and his fascination with mathematics, mechanics, and science had grown to the point where he was infatuated with them, like a lover whose every action is directed to the moment when he can return to his beloved's arms.

But regardless of the evolution of his reputation, his interests, and even his skills, the basic Leonardo had not changed. He remained the warm and considerate man he had always been, and a loyal supporter of friends and those who had come to depend on him, whether they were artistic and intellectual colleagues or simply members of his household, like the several handsome young men or boys who seemed always to be part of his life. He continued to read extensively, trying always to improve his knowledge of literature and science in order to assure himself that his art and his studies of mechanics and nature would be done with an understanding that, insofar as possible, precluded the kinds of error that are made out of ignorance. But to him, the greater errors were those arising from the abrogation of independent thought. Though he read and learned so that his store of information might be increased, Leonardo knew that the most direct path to truth is repeated personal experience with the phenomena and laws of nature: "The grandest of all books, I mean the Universe, stands open before our eyes," he wrote.

Of course, Leonardo had no way of knowing the extent of his debt to earlier thinkers. The medicine and anatomy of his time were dominated by the teachings of the second-century C.E. Greek physician Galen, as interpreted and transmitted by centuries of Arabic-speaking physicians. Galen and the Arabs were the background against which he sought new knowledge; *sotto voce* they continued to speak to him even as he was doing his best to avoid their influence.

Though more free of such inherent bias than would be any man for centuries to come, he was, no matter how lightly, nevertheless encumbered with certain general concepts of whose effect on his thought he would remain unaware.

The stored-up philosophies and questionable theories of his predecessors had no conscious appeal to Leonardo, though, and he had no wish to use them in his own formulations. "He who can go to the fountain does not go to the water jar," he proclaimed, and lived his entire investigative life in keeping with that precept, cutting through the vain pronouncements of the contemporary didacts with his own precise investigations, repeated over and over to be sure of their accuracy. He wore his designation of being "an unlettered man" with pride, as an emblem of seeking to be uninfluenced by judgments other than those he had arrived at by his own unbiased observations. His response to those who relied on previous thinkers to mold their beliefs was succinct and clear. Approaching his fortieth year, he had written in one of his notebooks:

I am fully conscious that, not being a man of letters, certain presumptuous persons will think that they may with reason discredit me by alleging that I am totally unlettered. Foolish folk! Do they not know that I might retort as Marius did to the Roman patricians by saying: "They who deck themselves out in the labors of others will not allow me my own." They will say that I, having no literary skill, cannot properly give words to that of

which I desire to treat. But they do not know that my subjects are to be dealt with by experience rather than in words: and experience has been the mistress of those who have written well. And so, as mistress, I will cite her in all cases. Though I may not, like them, be able to quote other authors, I shall rely on that which is much greater and more worthy—on experience, the mistress of their masters. They go about puffed up and pompous, dressed and decorated with [the fruits of] labors not their own, but those of others. And they will not allow me my own. They will scorn me as an inventor; but how much more might they—who are not inventors but vaunters and declaimers about the words of others—be censured.

In time, he would come to realize that his own constant reading and self-education had made him a man of considerable literary ability, his lack of fluency in Latin notwithstanding: "I have so many words in my mother tongue, that I am more concerned about not understanding things well than about lacking the words to express the ideas in my mind."

And another thing about Leonardo had not changed— he still seemed unable to finish many of the commissions that came to him. If anything, the situation was worse than it had ever been. As his preoccupation with science grew, he became increasingly impatient of anything that stood in the way of his investigations and the designs of his mechanical innovations. An example is a project he took on soon after returning to Florence.

The friars of the Order of the Servites at Santissima Annunziata had asked the artist Filippino Lippo to paint an altarpiece for them, but he withdrew upon hearing that Leonardo was interested in doing it. The monks installed the much-heralded luminary and the members of his household in their monastery and undertook to pay all of their expenses as well. Vasari describes the course of events that followed:

> He kept them attending on him a long while. At last he made a cartoon [a drawing to be used as model for the final work] with the Madonna, Saint Anne, and the infant Christ so admirably depicted that not only were artists astonished, but the chamber where it stood was crowded with men and women for two days, all hastening to behold the wonders produced by Leonardo. . . . Leonardo then painted the portrait of Ginevra, the wife of Amerigo Bengi, a most beautiful thing, and abandoned the commission entrusted to him by the Servite monks.

Nothing is known of why Leonardo left off his work for the monks and took up another job, but such behavior was hardly atypical for him. He did finish the Ginevra portrait, however. But Vasari most probably had his dates wrong, the painting having been done during Leonardo's first Florentine period, when, at twenty-one, he was only five years older than his subject. The biographer also errs somewhat in her name and situation. She was, in fact, the daughter of a wealthy banker of the city, Amerigo de Benci. Her image

now hangs in the National Gallery of Art in Washington, D.C., one of the few portraits considered somewhat complete by this painter, whose notions of perfection were based on criteria too lofty for most. Vasari says it best: "Leonardo, with his profound knowledge of art, commenced various undertakings, many of which he never completed, because it appeared to him that the hand could never give due perfection to the object or purpose which he had in his thoughts, or beheld in his imagination—since in his mind he frequently formed some difficult conception, so subtle and so wonderful that no hands, however excellent or able, could ever give it expression."

Yet these brief four years in Florence were nevertheless extraordinarily productive, at least in the number of paintings that came out of his studio and under his direct supervision. Though much of the output of this time no longer exists, there are sufficient extant records to show that, whatever may have been his reluctance, a great deal of artistic work was accomplished.

We have some notion of Leonardo's distractions during this second Florentine period, from the letter written to Isabella d'Este of Mantua in 1501 by Pietro di Novellara, which was quoted in Chapter I. It was well known in Florence that the master would occasionally add a stroke or two to paintings that his pupils were carrying out in his name, but was otherwise detached.

Although Leonardo was increasingly turning his attentions away from painting, he still had to make a living. An

opportunity to improve his financial fortunes was soon presented by the never-ending political upheavals of the Italian peninsula and the personal presence of Cesare Borgia, the prince of Machiavelli's opus.

In 1501 Pope Alexander VI gave his illegitimate son, the unscrupulous Cesare, the title of Duke of the Romagna, a wide area of central Italy. The pope's previous attempts at assuring his nefarious offspring's future had seen Cesare made archbishop of Valencia at the age of sixteen, and then cardinal a year later. But even in those days of treachery and corruption, there seem to have been some limits to what was tolerated, and the profligate Cesare soon demonstrated that he was unfit for the clergy. In any event, he was so ambitious for secular power that he renounced his position and replaced his miter with a warrior's helmet, determined to establish himself at the head of a hereditary principality regardless of the perfidy and ruthlessness that might be required to subdue the various provinces and cities of his intended suzerainty. He soon found himself greatly in need of a skilled military engineer-general and architect.

By the time he invited Leonardo to take up those duties, Cesare had achieved a number of dramatic military successes and was widely known for the viciousness of his tactics and the terrifying cruelty of his governance. Encompassing all of his claims in a single title, he grandly called himself "Cesare Borgia of France, by the grace of God Duke of the Romagna and of Valencia and Urbino,

Prince of Andria, Lord of Piombino, Gonfaloniere, and Captain-General of the Holy Roman Church." It was only by a bit of a stretch that he was "of France," his claim resulting from a recent marriage to Charlotte d'Albreta, the sister of the king of Navarre, upon which he had been given the title of Duke of Valentinois by Louis XII.

One would have thought that Leonardo, a man of sweet, pacific disposition to whom political maneuverings were anathema, would have balked at putting himself in the employ of such a tyrant; but that was hardly the case. Leonardo was, of course, the same man who had written to Ludovico Sforza of his plans for weapons of fearful destruction—the same man who throughout his life was fascinated by mechanisms and the design of various sorts of engines. He was also a man of great pragmatism. He had to support himself and those who had come to depend on him. Moreover, he wished to make himself so financially secure that he might pursue his studies untrammeled by the necessity constantly to earn money. To work for Cesare was no doubt to Leonardo simply a sensible decision. He had done this kind of thing before and he would do it again. Neither intrigue, politics, power nor ideology seem ever to have been involved. Leonardo's only motive was to make himself free to be Leonardo.

The assigned task was to inspect the fortresses and defenses of Cesare's dukedom, and to make whatever modifications and repairs were found to be necessary. The engineer-general's advice on armaments may have been the

reason that Nicolò Machiavelli, in an October 1502 dispatch from the Romagna, was able to write, "The Duke has so much artillery and in such good order that of himself he possesses almost as much as all Italy." Leonardo moved from city to city as they fell to Cesare's army and his scheming. Not only did he perform his duties as engineer-general, but he was able to take advantage of his travels to study the topography of the region, prepare maps, and investigate methods by which the marshes might be drained. He spent the summer of 1502 and the winter of 1502–1503 engaged in this work, returning to Florence when the campaign ended and Borgia went back to Rome in February 1503. His expectations of large financial rewards were not met—instead of a deposit, he had to make a withdrawal of fifty gold florins from his bank account, which he did on March 4. As for Cesare, he would soon face a series of misfortunes that ended with his ignominious death in an obscure skirmish with Navarrese rebels in 1507.

Leonardo's skills as a military engineer were soon utilized by the Florentines, and in July 1503 he was asked to advise the force that was laying siege to Pisa. He devised plans for a canal with an ingenious system of sluices and locks, in order to serve the double purpose of depriving the defenders of their water supply by diverting the Arno from the besieged city while providing Florence with a pathway to the sea. Construction was begun on the project in August, but for uncertain reasons was abandoned after almost two months.

Before long, the dissections at Santa Maria Nuova had been resumed (biographers disagree over whether they had been taken up during the first period of the Florentine return, in 1500 and 1501), facilitated by the location of Leonardo's residence, which was either close to the hospital or, as some commentators say, actually in it. By this time he had become quite skilled at dissection and was able to make certain meticulous observations that might previously have eluded him. Obviously, his increasing abilities made his work all the more interesting to him, and he was soon deeply engrossed in it. He describes meeting a man at the hospital who claimed to be a hundred years old and seemed in good health. Shortly thereafter, the ancient fellow suddenly died while sitting in bed, and Leonardo, who "examined the anatomy to ascertain the cause of so sweet a death," discovered that it was caused by "a weakness through failure of blood and of the artery that feeds the heart and the lower members which I found to be very parched and shrunk and withered; and the result of this examination I wrote down very carefully." And even more directly, "Vessels in the elderly through thickening of their tunics restrict the transit of blood, and, owing to this lack of nourishment the aged, failing little by little, destroy their life with a slow death without any fever."

As astonishing as it is to find such a statement in his notebooks, Leonardo was describing atherosclerosis of the aorta, and perhaps even coronary artery obstruction, hundreds of years before either was recognized by physicians.

What is meant by "the artery that feeds the heart" is open to interpretation, but it may be inferred, from the meticulousness of his later studies of these parts of the anatomy, that Leonardo had already recognized the coronary arteries to be branches of the aorta by which the heart is supplied. In any event, he was clearly pointing out that the withering of the lower members was due to their being inadequately nourished—"parched and shrunk and withered"—because of arterial obstruction. This was observed at a time when the universities were still teaching the thirteen-hundred-year-old Galenic belief that nutrition reaches the extremities through an ebb and flow mechanism that carries blood via veins originating in the liver.

The astuteness of Leonardo's observations was aided by somewhat of a coincidence. At about the same time as his dissection of the old man, he performed an anatomy on the body of a two-year-old child. He must have been much taken by the differences between the blood vessels in his two subjects, and of the condition of the structures they supplied. Although coming to the proper conclusion from such observations would seem perfectly straightforward to us today with all of the hindsight of the past 250 years of research in pathological anatomy, it is hardly likely that any other dissector of the time would have reached the same correct conclusions.

This second Florentine sojourn provided the occasion for an abortive tournament of the titans between Leonardo

and young Michelangelo, who by then had developed a considerable antipathy toward him. Until this point the joustings had been primarily verbal. The *Anonimo Gaddiono* tells of two such episodes. In one, Leonardo suggested to the prickly Michelangelo, twenty-three years his junior, that he explain some passage of Dante, only to be answered with, "Explain it yourself, you who made drawings of a horse in order to cast it in bronze and could not cast it, and out of shame had to abandon it." The *Anonimo* continues, "And having said this, he turned on his heel and went away, leaving Leonardo flushing red at his words." On another occasion, states the *Anonimo*, Michelangelo taunted his prey with, "And so they believed in you, did those capons the Milanese?" The very existence of Leonardo seemed to irritate the younger man, and it is difficult to believe that the sentiments did not in time come to be reciprocated by even one so patient as the Vincian, in spite of the forbearance for which he was known.

When the authorities decided that the newly constructed Council Chamber of Florence should be decorated with grand murals, they quite naturally turned to the two illustrious artists to do the work, on opposite walls. Leonardo's theme was to be the Battle of Anghiari, in which the Florentines defeated the Milanese in 1440; Michelangelo's was one in which a Florentine force was surprised by Pisans while bathing just before a battle.

Leonardo made great plans for his work, between the

lines of which may be read his entire philosophy of paint-
ing as the capture of a moment in the emotional experience
of its subjects:

> You must make the conquered and beaten pale, their
> brows raised and knit, and the skin above their brows fur-
> rowed with pain, the sides of the nose with wrinkles go-
> ing in an arch from the nostrils to the eyes, and make the
> nostrils drawn up and the lips arched upwards discovering
> the upper teeth; and the teeth apart as with crying out and
> lamentation. And make one man shielding his terrified
> eyes with one hand, the palm towards the enemy, while the
> other rests on the ground to support his half-raised
> body . . . Others may be represented in the agonies of
> death grinding their teeth, rolling their eyes, with their
> fists clenched against their bodies and their legs con-
> torted. Someone might be shown disarmed and beaten
> down by the enemy, turning upon the foe, with teeth and
> nails, to take an inhuman and bitter revenge. . . . You
> would see some of the victors leaving the fight and issuing
> from the crowd, rubbing their eyes and cheeks with both
> hands to clean them of the dirt made by their watering
> eyes smarting from the dust and smoke.

Although there were the usual intermittent delays,
Leonardo worked on the cartoons for his mural over a pe-
riod of two years, and in late 1505 was in the process of
painting. But once again, there were technical difficulties. It
is thought that the plaster on which the work was being
done was badly made, but for whatever reason the colors on

the painting's upper portion ran when the artist attempted to dry the work with the heat from a charcoal fire. The damage might have been repaired, but Leonardo abandoned the project and did not return to it, some say because he was more interested in the work he was then doing on the flight of birds. The evidence for this supposition is that he did, between the middle of March and the middle of April of 1505, write the pages that are called by that name, *On the Flight of Birds.* Interestingly, Michelangelo, too, left his mural incomplete, never carrying it beyond the stage of making the picture's cartoon.

Of the several reasons to regret the loss to the world of two such monumental undertakings—that would have placed the brilliant talents of Leonardo and Michelangelo in one room for posterity to wonder at—not the least is the missed opportunity to have seen directly the difference between the two men in their respective approaches to the human figure in action. To Michelangelo, action was displayed in the form of the tension of muscles; to Leonardo, action was equally the result of mechanical forces, but the expression of its underlying psychology was the true hallmark of the painter's art. He was a man who knew that the origin of movement is in the mind. It was unquestionably of his young antagonist that he would write, in 1514, "O anatomical painter. Beware, lest in the attempt to make your nudes display all their emotions by a too strong indication of bones, sinews and muscles, you become a wooden painter." Commenting on the surviving preparatory sketches

and engravings of what was to be called *The Battle of Anghiari*, C. J. Holmes, then director of England's National Gallery, told an audience of the British Academy in 1922, "With Leonardo, as ever, the motive is psychological. His aim is to illustrate the effect of what he terms the 'bestial frenzy' of war upon man, and in its animalism, its turbulent vigour, the design anticipates Rubens. Even the horses are infected by their masters' fury and fix their teeth in each other."

Leonardo offered to return the advance payment he had been given for the painting, but this was refused in the general acrimony resulting from the failure of the effort after so many delays. Meantime, Charles d'Amboise, Louis XII's governor-general of Milan, had requested the loan of the artist's services for a period of three months, which the Florentine authorities grudgingly gave after some protestations. Late 1506 or early 1507—some give the date as October 1508, after the election of Pope Leo X—found Leonardo back once again in the city where he had done such varied service for Ludovico Sforza.

Leonardo's departure from Florence does not mean that we too can leave it just yet. There are a few matters to catch up with, the first being the death of Ser Piero da Vinci in July 1504, having reached the great age of seventy-seven and leaving ten sons and two daughters. In that same year, there is a notation in one of the Leonardian notebooks of the death of Caterina and the cost of her last illness and burial. It will probably never be known whether this Caterina was Leonardo's mother or a servant of the same name.

Some biographers assert one and others the other, while still others make what would seem the more justified statement that the solution is not to be found. If the woman in question was indeed Leonardo's mother, this note would mean that he had probably been in contact with her through the years, although she is mentioned nowhere else in his notebooks. It might also have influenced his portrait of Mona Lisa, in ways that will presently become apparent.

The other matter left to be caught up in the strands of the narrative is that self-same portrait. And for this, we turn to Walter Pater's insightful and justly famed 1869 monograph on Leonardo, which Kenneth Clark would seventy years later call "monumental," commenting that anything an English critic—including himself—might subsequently write "will be poor and shallow by comparison."

To study Walter Pater's paean to Leonardo is to become immersed in a mood of almost preternatural sensitivity. Pater captured an emotional state without appreciation of which it is difficult to penetrate the aura in which the Vincian's creativity flourished. The reader somehow intuits in the artist a constant state of inner attentiveness, removed from the everyday concerns of living and doing, and it was surely recognizable to anyone who cared to observe. "[H]e seemed to those about him as one listening to a voice, silent for other men," wrote Pater of Leonardo, and "He seemed to his contemporaries to be the possessor of some unsanctified and secret wisdom." In those two brief

passages the renowned critic captured the essence of a watchful intensity that went beyond intellectual brilliance and even the burning curiosity of which Freud would later write. That voice spoke in the rhythms of which the *Mona Lisa* is the finest expression. Pater said of her face, "It is a beauty wrought out from within upon the flesh, the deposit, little cell by cell, of strange thoughts and exquisite passions. . . . All the thoughts and experience of the world have etched and moulded there."

If "the *Mona Lisa*'s smile is," as Kenneth Clark has written, "the supreme example of that complex inner life, caught and fixed in durable material, which Leonardo in all his notes on the subject claims as one of the chief aims of art," then an obvious question presents itself: Whose complex inner life is it, that centuries of observers have puzzled over and tried to explain? At whom are we looking when we contemplate the seemingly inscrutable face that gazes so directly back at us from the canvas, as if in communion with something within us that even we do not understand?

Perhaps it was Pater who has come closest to the answer. Of the young Leonardo in his first Florentine period, he wrote, "He learned here . . . the power of an intimate presence in the things he handled." Of the nature of the intimate presence, Pater can only conjecture. But the conjecture is made with a note of certainty, as though he had no doubt about his conclusions. In this connection, it is pertinent to recall his comment on Leonardo's "interfusion of the extremes of beauty and terror." The experience of life is epit-

omized in Leonardo's early adventure while exploring the hills near Florence: It is very like "the mouth of a huge cavern" in which fear and desire commingle and seduce even as they repel. In his analysis of the *Mona Lisa*, Kenneth Clark takes us just a bit further, though he too seems unaware of just how far he has traveled: "The picture is so full of Leonardo's demon that we forget to think of it as a portrait. . . . He sees her physical beauty as something mysterious, even a shade repulsive, as a child might feel the physical attraction of his mother." Here he brings us back to Freud, though these remarks in their own way echo Pater too, writing fifty-five years before the founder of psychoanalysis turned his thoughts to the *Mona Lisa*.

At this point, it would be well to go even further back, beyond Pater and even beyond Vasari, who provided almost all that is known of the genesis of the picture. We need to return to the real woman. Having become at the age of sixteen the third wife of the thirty-five-year-old Francesco del Giocondo, Mona Lisa di Anton Maria Gherardini was twenty-four years old in 1503, which was probably the midpoint of the four years during which Leonardo is thought to have worked intermittently on her portrait. Vasari tells us, "[W]hile he painted her, Leonardo had someone near at hand to sing or play to her, or to amuse her with jests, to keep from her that look of melancholy so common in portraits." One cannot help but wonder, as did Kenneth Keele and Freud before him, why the esteemed artist, so much in demand, should have chosen this partic-

ular woman to paint, when, as Keele puts it, "many richer and more famous women were clamouring to sit for him," including members of the upper nobility. And one may also wonder why the artist never delivered the painting to Giocondo, instead keeping it with him until the day he died. His stated reason was that it was unfinished, and perhaps he is to be believed, especially in light of Vasari's description of his attitude toward completion.

In Leonardo's own perfectionist mind that may have been true. Still, it is difficult to believe that he was able to retain what must have appeared to La Gioconda and her husband to be in every way an excellent and quite finished portrait, without having to overcome a great deal of their doubtless considerable resistance. He must have wanted very badly to keep it. And of course, he *must* have thought it incomplete, since its subject was in itself a perfection that even he could not duplicate on a mere canvas.

There is no end to the interpretations that have been made of the portrait of Mona Lisa, and mine will certainly not be the last. Freud, of course, asserted that "this picture contains the synthesis of the history of Leonardo's childhood." In that formulation, the smile he saw on Mona Lisa's face when she was being amused by the music and the jests evoked in him the memory of the smile of his mother. Keele, a clinical physician, took this image and brought it a step further: He was convinced that certain physical evidence indicates that La Gioconda was pregnant—hers is the smile of inner satisfaction that the miracle of life is be-

ing created within her body. One cannot help but be impressed by the case he makes for his thesis, including the position of the hands and their apparent slight puffiness, which may explain the absence of rings on the fingers of a prosperous married woman. The location of the hands and the draping of clothes suggest to him that an enlarged abdomen is being subtly obscured by both artist and subject.

Keele supports his contention by pointing to Leonardo's many anatomical sketches in which the processes of reproduction and pregnancy are portrayed, ranging from the well-known drawing of the act of coition to what may be the artist's most famous anatomical depiction, that of the fetus in the womb. In all, his is an argument well reasoned, especially when he adds to it a description of the background of mountains and lakes before which La Gioconda is placed. The association, he points out, "occurs in two other pictures [of Leonardo's] with motherhood as their central theme, in the *Virgin of the Rocks*, and in *St. Anne, the Virgin and Child*."

Like so many others, I am much persuaded of the thesis that the *Mona Lisa* is Leonardo's tribute to idealized motherhood, and in fact to his probably unconscious preoccupation with retrieving the early years during which he was the sole star in his mother's firmament, whether that mother was Caterina or the kindly, loving Albiera, or even both. The ambivalence is there, between the attraction and repulsion that Pater and Clark—and certainly Freud—postulate, and so is the enigma. But I have found myself

wondering about something else. That wondering arises from the nature of Freud's argument about the dynamics of homosexuality in certain men, an argument until recently accepted by much of the psychiatric community, it must be remembered, as one of the mechanisms that may cause or contribute to its occurrence. Even today, when the emphasis is on the biological—and specifically the genetic—origins of homosexuality, Freud's thesis has refused to pass quietly into history. Like other of his hypotheses that so many have nowadays rejected, it lingers, and finds expression when an imaginative search is undertaken for the hidden meanings of human behavior.

Freud's contention, it will be recalled, is that a young boy feeling threatened by the overpowering quality of a mother's love may resort to protecting himself by repressing his own love and putting himself in her place. In identifying with her, he thus in a sense becomes her. His love object becomes himself. He is Narcissus.

Given that the *Mona Lisa* does appear to represent an idealized motherhood; given that it is "full of Leonardo's demon," as Clark puts it; and given that Pater, when Freud had barely reached adolescence, recognized in the painting that "from childhood we see this image defining itself on the fabric of his dreams . . . What was the relationship of a living Florentine to this creature of his thought? By what strange affinities had the dream and the person grown up thus apart, and yet so closely together?" Given all of this, one can hardly escape the conclusion that *La Gioconda* is the

ultimate expression of the inner life of a man who lived by the proposition that the greatest art is that "which by its actions, best expresses the passions of the soul." By this is meant not only the subject's soul, but the artist's soul even more—not only the mother (who is, after all, ringless—and heavier than the fashionably slim young wives of the time, as Caterina would have been), but the son too. The *Mona Lisa,* Leonardo's idealized mother, is, I believe, also Leonardo—"the possessor of some unsanctified and secret wisdom," and therefore smiling that enigmatic smile. The artist is himself the subject of his art.

In certain significant ways, painting a portrait is like writing a biography, and even the metaphoric language by which the literary effort is described attests to the similarities. We "portray" our subject and "depict" his life, among other turns of phrase. Samuel Taylor Coleridge was writing of both when he wrote of only one: "When a man is attempting to describe another person's character, he may be right or he may be wrong, but in one thing he will always succeed, that is, in describing himself." And so it may be said, I would propose, of Leonardo and his *La Gioconda.* He was describing his mother and he was describing himself. How close to consciousness either description was, we can only guess. The author was creating biography and autobiography at the same time.

V

The Events: Milan, 1506–1513
Rome, 1513–1515
Amboise, 1516–1519
Age 54–67

THE SUMMONS by Charles D'Amboise that he return to Milan for three months was very likely a relief to Leonardo, promising a brief respite from trouble. The failure of *The Battle of Anghiari* must have occasioned considerable public disgruntlement, especially since it was well known that the ever-increasing time spent at his mathematical and scientific studies had distracted the artist from paying full attention to the work. Moreover, Milan was then politically much more stable than Florence, and certainly more so than it had been under Ludovico Sforza. It was about this time that the Hapsburg emperor Maximilian I recognized the French king Louis XII as the duke of Milan, and French military might assured that the city was free of the threat of invasion.

Whether on his own initiative or at the urging of D'Amboise, it soon became understood that Leonardo's sojourn was to be extended indefinitely. When Louis made his formal entry into Milan in May 1507, the artist had already been in the city for at least six months, having been

given the title of Painter and Engineer-in-Ordinary to the French Government. Almost certainly, it was this occasion to which Vasari refers when telling of the time that "the King of France came to Milan, and Leonardo was asked to prepare something extraordinary for his reception. He constructed a lion which advanced a few steps, then opened its breast which was entirely filled full of lilies." He was once again a contributor to the revels, even if no longer the master of all pageantry.

The six years spent in the service of the French king were more tranquil than any that Leonardo had known since he first sought noble patronage under Ludovico. Not only was he favored by D'Amboise but he received regular payment, which may have been the reason that he was able during this period to devote himself assiduously to his scientific interests. With a predictable income it was no longer necessary to accept commissions that he would too frequently leave incomplete. In fact, other than the famed sepia self-portrait nowadays so often reproduced, not a single artistic work of note dates from this second Milan period. Though that picture is of a man appearing to be older than his age of approximately sixty, the strikingly handsome features of his younger days remained with him, his face now that of a sage—serene as always, but now even majestic.

It was in Milan that Leonardo was able to give full vent to his ever-growing fascination with anatomy. His studies were afforded a considerable boost by a close friendship

he developed about this time with a remarkable young scholar named Marcantonio della Torre. Della Torre had recently been called to Pavia from the University of Padua, where he had been appointed professor of the Theory of Medicine at the age of twenty-five. The purpose of the offer from Pavia was that he might establish a school of anatomy. Some biographers write that the two first met in 1506 when Leonardo was in Florence, and others that it was not until as late in the Milan years as 1510. In either case, the association was relatively brief, because della Torre died in either 1511 or 1512 of the plague, in the city of Riva where he had gone to treat victims of an epidemic.

Though della Torre was thirty years Leonardo's junior, the chronological difference was of no consequence to an autodidact zealous to increase his knowledge. Because none of the younger man's works survive, there is no evidence to support Vasari's statement that Leonardo's role was merely to illustrate them, using his own dissections as the source. Very likely, the relationship was far more one of equals. The precise degree to which either man was the preponderant influence on the other is difficult to know, with most recent authorities doubting della Torre's dominance, relying on the fact that Leonardo was already well advanced in his anatomical studies by the time the two met. The young professor's role was probably to spur his friend on, to encourage him in his work, and to attempt—mostly without success, it must be admitted—to intro-

duce some plan or at least a modicum of discipline into his work. It would seem safe to assume that the relationship must have served sufficiently to influence Leonardo's dissections and their interpretation that thereafter they took on a sophistication that was previously lacking.

Leonardo was, in fact, too independent a thinker and too reliant on his own observations for his direction to have been overly influenced by della Torre, who was much under the spell of the anatomy in the works of Galen, virtually all of which was based on animal dissection and consequently erroneous in certain key details and concepts. One might also point to Leonardo's nomenclature of parts, which is for the most part Arabic in origin, rather than the Greek terminology that della Torre was said by his contemporaries to use. This would seem to indicate that Leonardo was educated far more by his own readings in contemporary texts, which were heavily Arabic-influenced, than by his friend's example. As in all other intellectual matters, Leonardo took what he needed to improve his understanding, and then went his own way.

Leonardo's intention to publish a formal treatise on anatomy is indicated by his own statement, to which reference was made earlier, in the writings brought together as the *Treatise on Painting*, that such a work would be completed by the spring of 1510. Perhaps it was at the urging of della Torre that he undertook to commit himself to so organized a project, but of course it never reached fruition; the major portion of the surviving anatomical

studies had to wait before they might be perused by scholars, until their rediscovery in Windsor Castle in the eighteenth century.

That Leonardo intended eventually to put his scattered investigations in order is also evident from another notation in a manuscript now in the British Museum, written at about this time. He was in Florence when he wrote it, temporarily absenting himself from Milan in order to pursue a lawsuit over his father's estate. When Ser Piero died without a will, seven of Leonardo's legitimate brothers had tried to prevent him from sharing in the inheritance, and they did the same in 1507 when an uncle died. The uncle had left each of the men a share, but the brothers tried to have the will set aside to exclude their bastard sibling.

The legal procedures dragged out over many months, during which Leonardo was forced to remain in Florence and had plenty of time to think about his work. The notation reads:

Begun at Florence in the house of Piero di Braccio Martelli, on the twenty-second day of March 1508. And this is to be a collection without order taken from many papers which I have copied here, hoping afterwards to arrange them in order each in its place, according to the subjects treated of; and I believe that before I come to the end of this I shall have to repeat the same thing several times, for which the reader must not blame me, because the subjects are many and the memory cannot possibly retain them and say, "I will not write this

because I wrote it before." For if I wished to avoid falling into this error it would be necessary that in every case when I wished to copy out a passage in order not to repeat myself I should read over all that had gone before, and the more so because of the length of interval between one time of writing and another.

In other words, Leonardo was letting any potential reader know that he had no intention of doing any editing, should he actually ever get down to the grindingly boring work of putting his oeuvre into publishable shape. Despite his brave statement, there is no evidence at any time during his seven decades of life that he ever stopped long enough in his constant pursuit of knowledge to allow himself the leisure to organize what he had discovered. There was always so much to do, so much to learn, that putting it into neat little piles of knowledge must have seemed a waste of time and talent. What is more, his studies were really undertaken for Leonardo alone, and not for any wider purpose of educating his contemporaries; it was with himself that his writings conversed. He seems to have had no notion of making some formal contribution to scientific progress, except in the sense that his findings would ultimately benefit posterity. His purpose was to satisfy his unquenchable thirst for figuring out how things work, and why. He was interested in the action, but it was the cause of that action that enthralled.

And there was plenty to enthrall during this second sojourn in Milan. More of the anatomical studies were now

being done on human materials than before, and the accuracy of the drawings of this period was markedly improved. Around 1513, Leonardo undertook a concentrated study of action and cause at the same time, as he focused on cardiac structure and function. Though most of the work was accomplished by studying the ox heart, he made some remarkable observations of internal cardiac structure and activity, alongside of which the meager knowledge claimed by anatomists of the time seems trivial.

Though the relationship with della Torre was all too short, Leonardo met another young man shortly after arriving in Milan whose friendship would prove crucial to posterity. While living just outside the city at the villa of Girolamo Melzi, Leonardo became interested in the artistic talent of his host's teenage son, Francesco. It was not long before the two developed what has been referred to as a father-son relationship, which formed so strong a bond between them that Leonardo took Francesco with him when he left Milan in 1513, and then to Rome and eventually to his final home in France. It was to young Melzi that all of the manuscripts would be bequeathed, as well as the books collected over a lifetime.

The tranquil years in Milan were doomed to end in a reversal of the self-same forces that had combined to make them possible in the first place. In those days of alliances quickly made and just as quickly broken, it was only a matter of time before the entente between Maximilian and the French king would dissolve. In 1508, they,

Ferdinand II of Spain, and Pope Julius II had formed themselves into what they called the League of Cambrai in order to subdue rebel forces in Genoa and force Venice to surrender certain newly acquired territories. No sooner had this been accomplished than Julius, in a complete about-face that stunned the French, allied himself with Venice, the Spaniards, and the Swiss, with the intention of reestablishing the Sforza dynasty. Though at first successful in repelling the new coalition's offensives, the French were finally defeated. On December 29, 1512, Ludovico's son, Maximiliano, entered Milan as its duke.

Leonardo thus found himself in a difficult situation. Though Maximiliano had known him as a highly regarded member of his father's artistic retinue, he also saw him as one of Louis's favored retainers. He would offer him no work. Without a patron, the sixty-one-year-old artist and his entire retinue of students, friends, and servants would have to move on. Once more, the Medicis intervened to influence Leonardo's destiny, or at least his immediate next step. In 1512, Giuliano de' Medici, a son of Lorenzo the Magnificent and an admirer and even a friend of Leonardo, had become head of the state of Florence in a bloodless coup. The following year, just as the Vincian was casting about for a place to call home, Julius II died and Giuliano's elder brother, Giovanni, was elected Pope Leo X. The new ruler of Florence advised his friend to move to Rome, and he gladly accepted the opportunity. A note in one of the manuscripts states simply, "I departed from

Milan for Rome, on the twenty-fourth day of September 1513, with Giovanni, Francesco de Melzi, Salai, Lorenzo and il Fanfoia."

Before long, Giuliano too found himself in Rome, Leo X having decided that he was too much a dreamer and an intellectual (or perhaps the problem was simply that he was too honest) to succeed in promoting the Medici interests in Florence. An imaginative man drawn to painters, architects, engineers, and even alchemists, he rather than the pope became Leonardo's patron. He saw to it that his Florentine friend was given a suite of rooms in the Belvedere Palace on the Vatican Hill, and an architect employed to redesign the space for workshops as well as the living area.

But if Leonardo thought that Giuliano's efforts in his behalf would result in some kind of golden period in this late autumn of his life, he was destined for disappointment. Younger men were in the ascendancy at the papal court, artistically in the person of the twenty-nine-year-old Raphael and the thirty-eight-year-old Michelangelo, both at the height of their achievement, and neither—particularly Michelangelo—pleased at the presence of the aged interloper. The resentful Michelangelo, in fact, very likely did what he could to undermine his old adversary. Latin being the language of Leo's court, Leonardo was disadvantaged also by his inadequate ability to communicate in such an atmosphere. But he found certain compensations in being given little work to do—there was plenty

of leisure to devote to studies in anatomy, mathematics, and optics.

Such preoccupations only added to Leonardo's reputation as a man easily distracted from completing what few artistic commissions he might be assigned. Leo must have seen him as a virtual soulmate of the impractical Giuliano. Vasari recounts the story of a picture having been assigned to him to paint, whereupon he began his project by commencing to distill certain herbs and oils to create a new form of varnish to put over the work when completed. To Leonardo, this was just a part of some ongoing experimentation he had been doing with new methods of preservation, but in the pope's eyes it was a dilatory form of procrastination, to avoid the actual undertaking expected of him, and he may have been at least partially correct. Vasari has the pontiff exclaiming, "Alas! This man will do nothing at all, since he is thinking of the end before he has made a beginning." Whether apocryphal or not, this little anecdote typifies Leonardo's general approach not only to the responsibilities assigned to him, but also to his priorities, which almost from the beginning had been determined far more by curiosity and inventiveness than by any practical need to fulfill the expectations of others.

Soon adding to the general difficulties arising out of his alienation from the court were the intrigues of certain of Leonardo's employees. Two German artisans seem to have conspired to steal some of his designs for mirrors

and to plant malicious rumors in the minds of certain of the pope's aides about purported sacrilegious irregularities in the anatomical studies he was doing at the Ospedale di Santo Spirito. "The Pope has found out that I have skinned three corpses," wrote Leonardo, doubtless in apprehension of the consequences. He appealed to Giuliano for help, but none was forthcoming because the patron was by then sick with the tuberculosis that would take his life only a few years later. When Leo X punished Leonardo for the reported anatomical indiscretions by prohibiting him from further dissections, Giuliano was unable to intervene. The great studies on the human body were terminated, never to be resumed with the same intensity. "The Medici created me and destroyed me."

Nor was Leonardo in the best of health either. The years had begun to take their toll, and some of the old vigor had deserted him. Others were noticing some problems with weakness and even a tremor in his right hand. But he persisted in the work that really interested him. Notes in the manuscripts tell of a stable he was designing for Giuliano, and of plans for a machine to coin money for the mints at Rome. Calculations for parts of cannon are also to be found in these pages. Although it cannot be documented, Leonardo must have retained his earlier interest in plans for the drainage of the Roman marshes, the kind of project in which he had been involved during his Milan periods as well.

In 1515, political events once more intervened in

Leonardo's life. Louis XII died on New Year's Day 1515 and was succeeded by his cousin Francis I, who lost no time in attempting to overthrow Maximiliano and reestablish French control over Milan. In July of that year, Giuliano, though in failing health, was sent in command of papal troops to frustrate his designs, the French army already having penetrated as far south as Florence. In a very short time, he had to turn over the leadership of the troops to his nephew and retire to Fiesole, where he died. Leonardo was once again without a patron.

It is uncertain where in this catalogue of events Leonardo met the French king. When Francis defeated the papal army in a decisive battle just southeast of Milan at Marignano (now Melegnano) and set his course toward Rome, Leo decided to enter into secret meetings with him to prevent further incursions. Perhaps it was at this time that Leonardo came into contact with the man who would become his next source of support. Remembering the high esteem in which Louis XII had held Leonardo, Francis invited the painter to accompany him after the successful conclusion of the conferences, when he led his troops northward back to France in December 1516.

Here, in the twilight of his life, Leonardo at long last found a patron worthy of his genius. It was too late for accomplishment but not too late for honor. In the remaining two and a half years of his life, he was treated like the revered emeritus professor he had in essence become. Francis gave him a comfortable stipend and the chateau of

Cloux—actually a small castle—to live in, near his own royal residence at Amboise. The king's frequent visits when the court came to Amboise had almost the nature of pilgrimages, as the monarch, though himself more a warrior than a person of culture, figuratively sat at the feet of the man whom he considered the greatest artist and philosopher of the age.

Something of the attitude of Francis toward Leonardo can be gleaned from a statement that would later be made by Benvenuto Cellini. Cellini arrived to work at the French court in 1540 and heard, directly from Francis himself, of the esteem in which his predecessor had been held:

> King Francis being violently enamoured of his great talents took so great a pleasure in hearing him discourse that there were few days in the year when he was separated from him, and it was for this reason that he did not have the opportunity of putting into actual use the splendid studies which he had carried on with such devotion. I feel I must not neglect to repeat the exact words which I heard from the King's own lips about him, which he told me in the presence of the Cardinal of Ferrara, the Cardinal of Lorraine, and the King of Navarre. He said that he did not believe that there had ever been another man born into the world who had known as much as Leonardo, and this not only in matters concerning Sculpture, Painting, and Architecture, but because he was a great Philosopher.

An insight into the circumstances of Leonardo's life during these final years is provided by the testimony of a traveler who journeyed to Cloux in 1517 to meet him. Cardinal Luis of Aragon, a half brother of the king of Naples, came to the chateau during an extensive European tour, and his secretary, Antonio de Beatis, left the following record of the visit:

> On the tenth of October 1517, Monsignor and the rest of us went to see, in one of the outlying parts of Amboise, Messer Lunardo Vinci the Florentine, an old man of more than seventy years, the most excellent painter of our time, who showed his Excellency three pictures, one of a certain Florentine lady done from the life at the instance of the late Magnificent, Giuliano de Medici, another of St. John the Baptist as a youth, and one of the Madonna and Child in the lap of S. Anne, all most perfect, and from whom, since he was then subject to a certain paralysis of the right hand, one could not expect any more good work. He has given good instruction to a Milanese pupil who works very well. And although the aforesaid Messer Lunardo cannot colour with the same sweetness as he used to he is still able to make drawings and to teach the others. This gentleman has written of anatomy with such detail, showing by illustrations the limbs, muscles, nerves, veins, ligaments, intestines, and whatever else there is to discuss in the bodies of men and women, in a way that has never yet been done by anyone else. All this we have seen with our own eyes; and he said that he had dissected more than

thirty bodies, both of men and women, of all ages. He has also written of the nature of water, of divers machines and of other matters, which he has set down in an infinite number of volumes all in the vulgar tongue, which if they should be published will be profitable and very enjoyable.

The vulgar tongue was, of course, the common or popular tongue, namely, Italian, the eloquence of whose vernacular had been recognized since Dante Alighieri celebrated it two hundred years earlier. Flowing from the fingers of Leonardo, its beauty of language sometimes reached heights hardly less poetic than that which the other great Florentine had described in his 1307 commentary on its literary merits, *De vulgari eloquentia.*

There are certain obvious errors in de Beatis's description, but otherwise he provided what is generally agreed to be an accurate image of Leonardo as he was in those final years. The picture "of a certain Florentine lady done from life" was not done at the instance of Giuliano but was in fact the *Mona Lisa,* which its artist had never allowed to escape his ownership.* And Leonardo, in spite of his appearance of age more advanced than it actually was, was sixty-five at the time of the cardinal's visit.

The reference to "the nature of water" could have referred to any of a wide variety of philosophical musings

*Kenneth Clark, virtually alone among the major authorities, disputes this and believes that it was a later picture.

recorded in the manuscripts or to the various projects of a lifetime, such as the building of systems of canals, the draining of marshes, and the diverting of rivers. But what is striking here is the attention paid by de Beatis to the anatomical work, very likely because Leonardo singled it out as particularly significant. Of all that a man of such diverse interests should have chosen to show a distinguished visitor, it is of no small consequence that his studies of the human body should have been paramount.

It is ironic that Leonardo's final safe harbor was destined to be a lovely chateau within twenty miles of the dank dungeon in which his first patron Ludovico Sforza had ended his unfulfilled life in captivity almost a decade earlier. One cannot but wonder whether as his forces waned the great Vincian ever regretted the many projects left incomplete, the scattering of his multitude of talents in so many diverse directions, the lack of concentration on some single focus of activity or at least on some very few—whether he believed that his life too, like Ludovico's, had been unfulfilled. If he did, there is no mention of it in his writings.

Vasari describes Leonardo's final months, no doubt from details given to him when he visited Melzi many years later, probably in 1566: "Finally, being old, he lay sick for many months. When he found himself near death he made every effort to acquaint himself with the doctrine of Catholic ritual." Notwithstanding his belief in God and in the existence of the soul, it was a ritual—and

indeed an entire formalized religion—from which he had in general kept himself separated, "holding lightly by other men's beliefs, setting philosophy above Christianity," as Pater put it. No wonder he needed to "acquaint himself with the doctrine," as the end of his life approached.

On Easter eve 1519, Leonardo made his will, leaving all his notebooks to Melzi and arranging for masses to be said at three different churches, as though in a final scattering of his heritage, an act symbolic of the dispersion of his talents. He died on May 2, having received the sacraments of the Church with so many of whose teachings on the history and character of the natural world he had disagreed.

And as for his soul—we can only guess where it went, but we do have Leonardo's reflections to consider. He believed that the soul depends on the body for its activities. In embryonic development, he wrote, the body "in due time awakens the soul that is to inhabit it." And elsewhere, "Every part is designed to unite with its whole, that it may escape from its imperfections. The soul desires to dwell in the body because without the body it can neither act nor feel." In this mechanistic model, the soul cannot function when the body dies. Perhaps it, too, dies. Whether or not this is true, none of us will ever know while we still breathe.

The Manuscripts

LIKE SO MANY OTHER men and women, I have spent a lifetime scribbling countless notes to myself, each of seemingly great importance when it was being jotted down. My intention was always either to have later transposed the message to some more permanent file or to have acted upon whatever was recorded. Almost every reader of this book has doubtlessly done this kind of thing many times.

Equally likely is that at least some of the self-directed notes have been composed in a kind of personal shorthand, or even code, easily understood by the writer but by no one else. The object of the apparent secrecy has not been to mystify any possible beholder, but simply to record the information as expeditiously as possible. When not lost, my messages have always been retrievable, regardless of length or abstruseness, although a bit of eyestrain or strain of memory might be required.

This is the way I understand Leonardo da Vinci's intent, over the approximately thirty-five years during which he scrawled the more than five thousand manuscript pages

of his extant writings, as well as those many undoubtedly lost. Beginning in Milan sometime after his thirtieth year, he began a process that amounts to setting down on paper a long series of notes to himself, some of which were random and brief, and some of which were well constructed studies of one or another problem of an artistic, scientific, or philosophical nature, usually accompanied by either elaborate or simple drawings. In fact, it would be more correct to say that the drawings—left in various stages of completion—are accompanied by notes, since the former are of far greater significance. The sizes of the manuscript pages vary from quite large, as most of them were, to as small as three and a half by two and a half inches. More than half of the material is on loose sheets and the rest is in notebooks of various kinds. To add to the jumbling, Leonardo sometimes used folded sheets of paper which he later separated and arranged in pages, in such a way that the original juxtaposition was confused.

Almost always, an observation is complete on the page where it appears, although there are a very few instances, in bound volumes of numbered pages, where one finds the instruction "turn over," and "this is the continuation of the previous page." There is no punctuation, no accenting, and a proclivity toward running several short words together into one long one. Just as likely to be encountered is the division of a long word into halves. And once in a while, one comes across words or proper names in which the order of the letters is scrambled, as though in great

haste. Some of the letters and numbers are written according to Leonardo's own sometimes inconsistent orthography, and they are at first difficult to decipher until one learns to recognize them, as well as to decipher certain shorthand terminology. In all, these are the personal idiosyncrasies of a personal note taker.

And then there is the so-called mirror writing. Leonardo wrote from right to left, adding considerably to the difficulty of transliterating his manuscripts. It is probably because of the mirror writing that he sometimes turned the pages of his notebooks in the reverse order, so whole sections can be found running back to front. A page of his scrawl is likely to contain a scientific discussion alongside a personal notation concerning daily household doings, and perhaps a sketch without text or text without a sketch or text and sketch all together in a completely lucid arrangement. When seemingly irrelevant notes and drawings are placed on some particular page, they are not infrequently found, when carefully scrutinized by experts, to be not irrelevant at all, but to have either direct or indirect applicability to the rest of the nearby material.

Although there is the volume that has been called since shortly after Leonardo's death the *Treatise on Painting*, its unity is the work of an unknown compiler who brought what he considered to be the appropriate pieces together into a unified form. The codex *On the Flight of Birds* does have something of a completeness about it, but other of the studies on flight are scattered through Leonardo's

pages as well. In all of the manuscripts, there is not a single whole work as we conceive of it. What we have been left by Leonardo are the equivalent of thousands of those pieces of paper on which we have all recorded urgent messages to ourselves. Unfortunately, many of them are lost.

Certain of Leonardo's pages were not only never lost, however, but actually were revisited again and again. He might return to a particular sheet at intervals of weeks, months, or even many years in order to add drawings or notes as he learned more about a topic. Most notable in this regard for his anatomical research was his series of drawings of the brachial plexus, a complex bundle of interwoven and branching nerves that supplies the arm from its origin in the spinal cord of the neck. Leonardo's first and final drawings of the perplexing leash of fibers were separated by some twenty years.

Although demanding to read, writing as though seen in a mirror is far less difficult than might be supposed. Left-handed people in general find it quite easy, and it may in fact be more natural to them than standard script. Schooling drills the tendency out of young lefties, but the technique is easily picked up again. Many righties, too, can write right to left in a legible hand. And there is strong, albeit not certain, evidence that Leonardo was left-handed. Luca Pacioli referred to his friend's left-handedness in his own writings, as well as did a man named Saba da Castiglioni, in his *Ricordi,* published in Bologna in 1546. It has also been pointed out that the direction in which

Leonardo customarily drew his shading lines is that of a naturally left-handed person, from left to right diagonally downward.

From all of these considerations, it would appear that there is no mystery in Leonardo's motives for writing as he did. He was almost certainly a lefty keeping notes, scribbling them as fast as he could because his hand was unable to keep up with the quickness of his mind. What some have thought a code seems to have been merely the personal scrawl of a man whose stylistic idiosyncrasies were a kind of shorthand to enable him to put things down on paper as quickly as possible. There is plenty of evidence from various of his comments that he intended eventually to collate much of this material, which would have been just as accessible to him as though he had written it in the standard way, even if to no one else.

As convincing as the foregoing might be, it still remains possible that Leonardo did indeed deliberately record his thoughts in such a way that they would be indecipherable to any but those so determined to understand them as to be willing to devote long hours to the process. Vasari wrote that he had been a heretic, and more a philosopher than a Christian; some must have thought him a crypto-atheist; not a few of his notions were far from those of the Church. This is the man, it will be recalled, who wrote, long before Galileo was accused, "The sun does not move." And this is the man also who saw evidence everywhere, whether in the form of fossils, rock

formations, or the movements of water, of the great age of the earth and of the constantly changing character of its geologic and living forms. Not until the studies of Charles Lyell early in the nineteenth century would there again be encountered a scholar who theorized with such clarity that the characteristics of the earth's surface are the result of processes taking place over enormously long periods of geological time. "Since things," he wrote, "are far more ancient than letters, it is not to be wondered at if in our day there exists no record of how the aforesaid seas extended over so many countries; and if, moreover, such record ever existed, the wars, the conflagrations, the deluges of the waters, the changes in speech and habits, have destroyed every vestige of the past. But sufficient for us is the testimony of things produced in the salt waters and now found again in the high mountains far from the seas."

Leonardo depicted that testimony in some of his paintings, specifically in the *Virgin of the Rocks*, the *St. Anne*, and the *Mona Lisa*. In the background of each can be seen the primeval world as he must have imagined it was before it evolved (I choose the word advisedly—he came close to describing the theory of evolution) into its modern form. As a man who more than once proclaimed that everything is part of everything else, he surely related the generation of the world to the generation of a human being. His fascination with the one was of a piece with his fascination with the other.

It was unpredictable nature that Leonardo saw as the

creator of the ever-changing wonders of the earth, and he did not hesitate to say so: "Nature, being inconstant and taking pleasure in creating and continually producing new forms, because she knows that her terrestrial materials are thereby augmented, is more ready and more swift in her creating than is time in his destruction." There is no mention here of God, and certainly no room for the biblical Creation story. Regardless of my own conviction to the contrary, perhaps considerations like these should be factored into any theory attempting to understand the totality of why Leonardo should have chosen to write so inaccessibly. The dangers of easily discovered heresy in that Church-dominated time cannot be underestimated, as we know all too well from the treatment not only of Galileo, but of others too, who dared to question doctrine.

The Leonardian notes have been mastered by a small band of scholars over the centuries, whose labors provide a precious record of their author's thought for the rest of us to ponder. Even the scattered quotes appearing throughout this book suffice to demonstrate the power of the Vincian's language. To the titles of painter, architect, engineer, scientist, and all the others must be added literary craftsman. What is most remarkable about some of the soaring flights of language and contemplation is the very fact that they seem to have been meant for their author's eyes only, the considerations of heresy notwithstanding. The aesthete, the observer of man and nature, the moral philosopher

who comes forth from the manuscript pages is speaking from the depths of his understanding and the power of his most profound emotion, as though in a constant stream of consciousness extending over a period of more than thirty years. Here there is no inner censor, only the crystal-clear voice of honesty, conviction, and—most remarkably for his era—a refreshingly open-minded curiosity.

Had Leonardo set out to record a volume of the principles by which he lived his life, or a book of aphorisms for which he wished to be remembered, or a compendium of his interpretations of the universe and its relationship to mankind—had any of these been his intention, he could not have accomplished them more effectively than he did in what would appear to be a scattershot miscellany of random thoughts sprayed over the pages of his loose sheets and notebooks, amid sketches, architectural plans, scientific observations, mathematical constructs, quotations from other authors, and records of daily life. He exposes at once his innermost musings and the overt thrust of the message he devoted his life to transmitting: That a human being can be understood only by turning toward nature; that the secrets of nature are discoverable by observation and experiment free of preconception; that there are no bounds to the possibilities of man's understanding; that there is a unity between all elements in the universe; that the study of *form* is essential, but the key to understanding lies in the study of *movement* and *function*; that the investigation of forces and energies will lead to the ulti-

mate comprehension of the dynamics of nature; that scientific knowledge should be reducible to mathematically demonstrable principles; that the ultimate question to be answered about all life and indeed all nature is not *how*, but *why*.

"That a human being can be understood only by turning toward nature." This is a notion far more encompassing than it may at first seem. Leonardo's thought is infused with the ancient thesis that man is a microcosm of the great macrocosm that is the universe. In his thinking, though, this was not a spiritual concept, but a mechanistic one governed by the forces of nature. All arises from all else and all is mirrored in all else. The structure of our planet is like the structure of a man:

> Man has been called by the ancients a lesser world, and indeed, the term is rightly applied, seeing that man is compounded of earth, water, air and fire, this body of the earth is the same. And as man has within himself bones as a stay and framework for the flesh, so the world has the rocks which are the supports of the earth; and as man has within him a pool of blood wherein the lungs as he breathes expand and contract, so the body of the earth has its ocean, which also rises and falls every six hours with the breathing of the world. As from the said pool of blood proceed the veins which spread their branches through the human body, in just the same way the ocean fills the body of the earth with an infinite number of veins of water.

Some of the aphorisms in Leonardo's writings have the soaring quality of biblical verse, and even parallelism, reminiscent of Proverbs, Psalms, or Ecclesiastes. Here is the Leonardo who famously wrote, "Beauty in life perishes, not in art," expressing his certainty that painting is art's highest form: "Thirst will parch your tongue and your body will waste through lack of sleep ere you can describe in words that which painting instantly sets before the eye."

And on his notion of the immortality that we make for ourselves by the way we live our lives and the heritage of accomplishment we leave to posterity: "O you who sleep, what is sleep? Sleep resembles death. Oh, why not let your work be such that after death you acquire immortality; rather than during life you make yourself like unto the hapless dead by sleeping." And elsewhere, a corollary statement: "Avoid that study the resultant work of which dies with the worker."

And this, sounding as though it came whole from the pages of Proverbs: "Call not that riches which may be lost; virtue is our true wealth, and the true reward of its possessor. . . . As for property and material wealth, these you should ever hold in fear; full often they leave their possessor in ignominy, mocked at for having lost possession of them." All of these thoughts spring from the man some of whose contemporaries accused of being "totally unlettered."

Of course, many of the notations are far from being so lofty. There were lists of books to read or acquire; and there were recordings of the mundane activities involved

in caring for a large household and directing a workshop of artists and artisans; and there were letters to various patrons complaining of nonpayment. Thus, in the patched-together volume that came to be called the *Codex Atlanticus*, these words are to be found in a fragment of a letter that was to be sent to Ludovico Sforza during the first Milan period: "It vexes me greatly that the fact of having to earn my living [by accepting outside commissions] has forced me to interrupt the prosecution of the work which your Lordship entrusted to me; but I hope in a short time to have earned enough to be able with a calm mind to satisfy your Excellency, to whom I commend myself; and if your Lordship thought that I had money your Lordship was deceived, for I have had six mouths to feed for thirty-six months and I have had fifty ducats."

Never one to hide his talents under a bushel, Leonardo was not averse to lauding himself when the occasion called for it, as in this statement from a letter of the same period, to an unknown recipient. "I can tell you that from this town you will get only makeshift works and unworthy and crude masters: there is no capable man, believe me, except for Leonardo the Florentine, who is making the bronze horse for Duke Francesco, and who has no need to praise himself, because he has a task which will take him all his life, and I doubt that he will ever finish it, because it is such a large work."

Every once in a great while, the reader encounters a statement so prescient that it is necessary to stop and read

it again and then yet again, to be certain that it is being interpreted correctly. Leonardo introduced so many new concepts that there is a tendency to credit him with more than he actually deserves, and one must be cautious lest there be overinterpretation of some of his statements. But it is nevertheless not possible to avoid the thought that he is in the following passage elucidating the basis of the evolutionary principles that in numerous other manuscript pages he undoubtedly expresses in his observation of geological formations, waters and fossils. "Necessity is the mistress and the teacher of nature," he writes. "It is the theme and the inspiration of nature, its curb and eternal regulator." The necessity is the need to stay alive—it is the catalyst for the evolutionary process.

In like fashion, he seems to have understood the principles that would in later centuries come to be called inductive reasoning, and the role of experimentation in elucidating the general laws of nature:

> First I shall make some experiments before I proceed further, because my intention is to consult experience first and then by means of reasoning show why such experiment is bound to work in such a way. And this is the true rule by which those who analyze natural effects must proceed; and although nature begins with the cause and ends with the experience, we must follow the opposite course, namely (as I said before), begin with the experience and by means of it investigate the cause.

Such a way of proceeding was unheard of in Leonardo's day. It was seventeenth-century thinking at a time when the great mass of philosophical men were doing just the opposite, namely, expounding overarching theories to explain their experiences and observations. It would be well more than a century before William Harvey, the discoverer of the circulation of the blood, put into a brief sentence the new principle that the "unlettered" Leonardo had brought forth from a virtual scientific vacuum: "We confer with our own eyes, and make our ascent from lesser things to higher."

The treasure trove of Leonardian manuscripts has come down to the present day by a variety of routes, from their original provenance in the possession of the faithful Francesco Melzi. Melzi's feelings for his friend and mentor are apparent not only from the accounts of contemporaries, but in a letter as well, written by him to Leonardo's brothers to inform them of his death. "To me he was like the best of fathers," wrote the young man who had left his own biological father to be with Leonardo, "for whose death it would be impossible for me to express the grief I have felt. . . . It is a hurt to anyone to lose such a man, for nature cannot again produce his like."

After Leonardo had been buried in the cloister of the Church of St. Florentin at Amboise his will was read, in which the testator gave the twenty-six-year-old Melzi "in remuneration for services and favours done to him in the

past, each and all of the books the testator is at present possessed of, and the instruments and portraits appertaining to his art and calling as a painter."

Melzi soon returned to his family's villa in Vaprio, near Milan, where he allowed certain favored visitors, but only those he thought qualified, to look at the writings. He made an attempt to organize the material, succeeding by the end of his life in compiling a total of 344 short chapters of selections, but even those remained in a state of confusion and were never published. In 1566, he was visited by Vasari, who noted that certain portions of the manuscripts relating to painting had already passed from the old man's ownership. Treating of "painting and design in general and his theory of color," and also containing remarks on anatomy and the proportions of the body, these pages were said to be in the possession of an unnamed artist in Milan. Very likely these are the manuscripts that make up the book that has come to be known as the *Treatise on Painting,* first published in Paris in 1651 and in a more complete version in 1817. But Melzi had refused offers for others of the writings and insisted on keeping them together. When he died in 1570, his nephew and heir, the lawyer Orazio Melzi, felt free to dispose of them as he saw fit. It appears, in fact, that the tutor of Orazio's children took some and others were given away. A group of the manuscripts fell into the hands of the sculptor Pompeo Leoni, who was in the service of Philip II of Spain, to whom he had promised to give them. He did, in fact, take

them to Spain, but Philip died before Leoni could fulfill his intention. Instead, he made a single large volume of cut-out portions of some of them together with some seventeen hundred drawings and sketches, of which a goodly number were loose and seemingly unrelated. To this 1,222-page volume, which is essentially a scrapbook, he gave the name *Codex Atlanticus.* How much he threw out will never be known. When Leoni died in 1610, this book plus some other of the manuscripts went to his heir, Polidoro Calchi, who sold them to Count Galeazo Arconati in 1625. By this time, the existence of the Leonardian writings had become well known, and they were considered extremely valuable. In 1636, Arconati presented the *Codex Atlanticus* to the Ambrosian Library in Milan together with eleven other volumes of Leonardo's. Since the library had been given another volume by its founder, Cardinal Federico Borromeo, in 1603, it now owned a total of thirteen. Certain of the writings had fallen into the hands of other owners as well, and among them were undoubtedly at least a few that were later lost.

When Napoleon invaded Italy in 1796, he claimed the manuscripts as the spoils of war, resulting in the transfer of the *Codex Atlanticus* to La Bibliothéque Nationale and the other twelve volumes to the library of L'Institut de France in Paris. Each of the twelve was carefully examined and then described, for the very first time, in a text written by J. B. Venturi. To this day they are known by Venturi's designation of letters beginning with *A.* After the defeat

of Napoleon, the *Codex Atlanticus* was returned to the Ambrosian Library, where it now exists in the form of twelve volumes of manuscript detached from Leoni's album and properly remounted. The other texts remain in Paris to this day, with one exception: Originally bound together with manuscript *B*, the notebook *On the Flight of Birds* was separated and stolen sometime in the first half of the nineteenth century, and by a series of obscure travels the book now resides in the Library of Turin.

Others of the manuscripts originally owned by Melzi somehow made their way to England. These appear to have been among the ones left in Spain by Pompeo Leoni. In 1638, their Spanish owner sold them to Thomas Howard, earl of Arundel, at the time traveling in Spain. Howard took them to England and seems to have presented them to Charles I. As the *Codex Arundel*, a part of these was donated to the Royal Society in 1681 and then placed in the British Museum in 1831. The remainder, including the anatomical drawings, were sent to the Royal Library at Windsor, where they were deposited in a large, locked chest, along with some drawings by Hans Holbein, and were not rediscovered for more than a century. Various of the English portion of the manuscripts are now in the Royal Library at Windsor, the British Museum, The Victoria and Albert Museum (where they form the Forster Collection), and until recently in the Leicester Collection at Holkham Hall. The Leicester Codex is now owned by the Microsoft billionaire, Bill Gates. Kenneth Keele has es-

timated that only one third of Leonardo's original notes exist today, or at least any others have not yet been found.

But there is hope, at least for those manuscripts once known and now thought to have irretrievably disappeared. As recently as 1965, two notebooks apparently long gone were rediscovered in Spain's Biblioteca Nacional. The first, now known as Madrid Codex I, deals with applied and theoretical mechanics, while the second, Madrid Codex II, is a miscellany of notes on a variety of topics such as painting, fortifications, canal building, geometry, and optics.

The losses began early, since the material received by Melzi was only what Leonardo had brought with him to France. It is known, in fact, that a significant part of the anatomical work was left in the Hospital of Santa Maria Nuova in Florence when the move was made in 1516, and therefore lost. Later losses can only be guessed at. For example, the Duke of Ferrara was told in 1523 that among Melzi's possessions were *quelli libricini di Leonardo di Notomia,* but *libricini* suggests that the anatomy studies were in pocket notebooks, and none of the Windsor Castle materials is in this form.

To study and make sense of the extant manuscripts is an intellectual task of Herculean proportions. Leonardo seems sometimes to have lived under a compulsion to record everything he knew, or at least every problem with which he concerned himself. Even had scholars the opportunity of perusing the writings in their untouched form, they would have presented a jigsaw puzzle of observa-

tions, conjectures, and unrelated thoughts with no attempt at order and little separation of one category or time period from another. But given the cutting and pasting of, for example, the *Codex Atlanticus*, and the hodgepodge that has been made of some of the other already cluttered originals, not to mention the absence of bridging material that may have been present in some of the notebooks and sheets now lost—the result is a kind of literary and scientific pandemonium. Fortunately for posterity, the challenge has served to stimulate several generations of Leonardo scholars, particularly in our time. They, and through their work we, have been rewarded with the victory of becoming acquainted, even if as yet incompletely, with perhaps the most diversely expansive mind this world has ever known, and certainly the most engaging.

The Anatomy:
"Things Pertaining to the Eyes"

WHEN LAST ENCOUNTERED HERE, a group of the Leonardian manuscripts that had made their way to England during the seventeenth century had been safely deposited in a locked chest. But locked chests have a way of disappearing, or at least being forgotten, when their owner is beheaded and a new regime takes over. This is precisely what happened as a consequence of the English Civil War and its aftermath. At an uncertain date, probably 1778, the chest was accidentally rediscovered in Windsor Castle by the king's librarian, Robert Dalton, who had no idea either of what was in it or where its key might be. On breaking the mysterious box open, Dalton was astounded to find what it contained. He must have immediately recognized the contents' value, since by that time the legend of Leonardo's anatomical studies had long been widely disseminated throughout Europe, although most of the factual evidence of it was, until that moment, nowhere to be located. The legend had rested on the drawings and notes included in the *Treatise on Painting*, and the widely circulated rumor that there was a great deal more, if only it could be found.

In 1784, England's leading anatomist, William Hunter, asked for permission to study the collection, having heard that it included 799 drawings (only 600 remain today, the others having unaccountably been lost), about 200 of which were of the structures of the human body. He was taken aback by what he saw:

> I expected to see little more than such designs in anatomy as might be useful to a painter in his own profession. But I saw, and indeed with astonishment, that Leonardo had been a general and a deep student. When I consider what pains he has taken upon every part of the body, the superiority of his universal genius, his particular excellence in mechanics and hydraulics, and the attention with which such a man would examine and see objects which he was to draw, I am fully persuaded that Leonardo was the best anatomist at that time in the world.

As fervent as it is, Hunter's encomium is an understatement. Not until Andreas Vesalius published his magnificent disquisition *De humani corporis fabrica* in 1543 had there been a work that even approached Leonardo's in its anatomic accuracy and detail. Vesalius is properly credited with bringing the study of the human body into its first modern form, but Leonardo did it before him—although few save Leonardo knew about it. To make drawings directly from a cadaver was an enterprise never previously undertaken at the time he conceived of it. In fact, physicians of the pe-

riod regarded drawings as distractions from the text, using them only to support theoretical constructs about which the student was meant to learn by reading. That many medical teachers continued for centuries after to be antagonistic toward pictures is shown by a comment in a review of the first edition of *Anatomy Descriptive and Surgical* (*Gray's Anatomy*) in the *Boston Medical and Surgical Journal* of July 1859: "[L]et a student have general illustrations, and just so surely will he use them at the expense of the text." Condemning Henry Gray's liberal use of detailed drawings, the reviewer substantiated his argument by pointing to contemporary texts that he called "two of the most successful anatomical books ever published, both of which have gone through several editions, and neither of them has a single illustration." The reviewer was Harvard's professor of anatomy, Oliver Wendell Holmes, and the publication in which he wrote was the predecessor of the *New England Journal of Medicine*.

Even the great Vesalius could not so much as approach the far greater Leonardo in his comprehension of the mechanics of the body, the ways in which the various structures carry out their various functions, and the clarity of their appearance in the illustrations that adorned his text. Like those in the Windsor Castle chest, some of Leonardo's discoveries in a multitude of areas had to wait many years, and sometimes centuries, to be rediscovered.

It would also be many years—until the middle of the twentieth century, in fact—that a full elucidation would

be possible of the magnitude of Leonardo's anatomic and physiologic accomplishment or even the depth of his knowledge. To Leonardo, the human form was a body in motion, every one of whose movements and activities, external and internal, is in accordance with the principles of mechanics and therefore accessible to objective investigation. How remarkable a concept this was may be appreciated by considering that for centuries after his time, many—perhaps most—scientists continued to invoke supernatural factors to fill gaps in their knowledge and explain phenomena that they had not yet fully elucidated by their experimental studies. To scientists of this conviction, certain phenomena would forever remain unexplainable by research, because they belonged in the realm of the spiritual. To deny the influence of such factors was beyond heresy, it was blasphemous.

But even a word like *remarkable* beggars any description of the magnitude of the forward leap that Leonardo's investigations represented, from what existed when he first took up his dissecting knife. Since the second century C.E., not only anatomy but all medicine had been dominated by the writings of Galen, a Greek physician working primarily in Rome, who had so imperiously codified his concepts of the human body in health and disease that they became the source from which all subsequent theorists began their speculations. To question the magisterial Galen was to question the entire framework of medicine as it was then understood, and no one had yet dared to attempt what

would have been universally viewed as an outrageous departure from orthodoxy. In the minds of all medieval and Renaissance physicians, the authority of Galenic teachings was equivalent to the authority of Church doctrine. Whether they wrote in Greek or in the Arabic by which all classical texts were transmitted until the early Renaissance, medical writers of the time were no more than redactors and expounders of the works of Galen, with occasional bows to Aristotle when the two were in any form of disagreement.

Galen's formulations, published in the equivalent of twenty-two octavo volumes of closely printed material, were based on the dissection of animals and theoretical speculations imbued with the conviction that a supreme artisan created and guides the activities of all structures in nature. His teachings were not founded on detailed knowledge of human structure, but rather on certain all-encompassing and fanciful theories of function, or physiology. To Galen and the physicians who mindlessly memorized his dicta for almost a millennium and a half, disease was a generalized process mediated by imbalances of the four humors, blood, black bile, yellow bile, and phlegm, in concert with the four qualities of hot, cold, dry, and wet. In such a speculative system, there was no virtue in knowing the details of an organ's structure or the finer points of its actions, since Galen's schemata had provided all that was required to practice the art of medicine. The few drawings in medical texts were representational rather than truly

anatomical, primitive in their crude approximations of reality. There was no need for them to be otherwise, especially since their only intended use was to facilitate understanding of the humoral notion of disease. In fact, before Leonardo, no one had thought it important to draw faithfully any structure deeper than the most superficial muscle layer of the abdominal wall.

The prescribed anatomical text being used in all Italian universities in the late fifteenth century was the *Anathomia* of Mondino di Luzzi, who had been a professor at Bologna, and whose notions of anatomy and disease were much influenced by the Arab interpreters of Galen. Of these, most prominent were Avicenna (Abu Ali al-Hussein ibn Abdalla ibn Sina, his full name in the original Arabic), whose *Canon* had been brought forth early in the eleventh century, and the Cordovan physician Albucasis (Abu'l-Qasim), whose *Meliki* appeared about fifty years later. Written in 1316, the *Anathomia* was an octavo volume of only forty pages. It included instructions for dissecting, Mondino having been one of the few teachers of the time known to have opened bodies himself, even if only to take a hurried look inside. Manuscript copies were widely disseminated throughout Europe until 1478, when the first printed edition of the book appeared. Between that year and 1580, thirty-three editions were published (the word *edition* was at that time used for either a reprinting or a truly new version), including those bound into seven editions of a widely circulated book called *Fasciculus medicinae*,

written by an author of uncertain identity known as Johannes de Ketham. The *Fasciculus*, originally produced in 1491, was a series of writings on venesection and surgery containing the first woodcuts in any medical text. The crucial edition of the *Anathomia* for Leonardo seems to have been the one published in Italian in 1494. He refers (not in a complimentary way) to Mondino's book in his manuscripts, and it may have been the means by which he instructed himself in his first approaches to dissection. The nomenclature he uses is so like that of the *Anathomia* that there can be little doubt of its influence on him.

Although the *Anathomia* provides some superficial descriptions of the organs of the body, much of its text is based on Arabic interpretations of Galen. There are other books to which Leonardo refers, but none of them goes beyond the medieval tenor of Mondino's. The *Anathomia* contains no illustrations but a standard drawing circulated widely at the time that had been in existence for almost a century, to which teachers and students customarily referred. This, the earliest printed figure of the anatomy of the internal organs, was used in the *Fasciculus medicinae*, into which Mondino's *Anathomia* was bound. It is the drawing to which Leonardo's depiction of the same structures, drawn during the time he was painting the *Mona Lisa*, must be compared in order to have some notion of the distance he was carried by the flying leap of his inspiration. One can only imagine what thoughts must have passed through his mind as he looked at his accomplishment alongside the

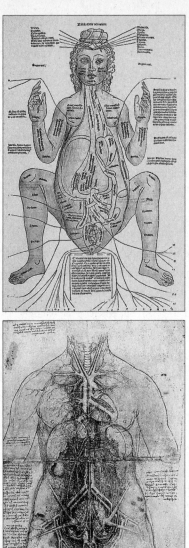

Anatomy of the female, as depicted in the *Fasciculus Medicinae.*

Leonardo's anatomy of the female.

received knowledge of his time. Whatever they were, he kept them to himself. In distinct contrast to the custom of the period, nowhere in his writings does he compare his own findings with those of any predecessor.

And how was that received knowledge in fact received? For this, we have the testimony of Andreas Vesalius, who, three decades after Leonardo's death, described the method of teaching as it then existed in the universities of Europe. For at least a century, the dissection of the human body had been part of the education of all formally trained physicians, with the consent of the Church. In 1543, Vesalius included in the preface to *De humani corporis fabrica* the following scene of a typical professor's typical anatomy demonstration. These exercises were carried out once or twice a year to fulfill a requirement of the curriculum, with the primary aim of demonstrating the truth of Galen's statements. They served as the students' only experience with a cadaver. To Vesalius, the entire proceeding was

A detestable ceremony in which certain persons [surgeons employed for the purpose] are accustomed to perform a dissection of the human body, while others [the professor or his assistant] narrate the history of the parts; these latter from a lofty pulpit and with egregious arrogance sing like magpies of things whereof they have no experience, but rather commit to memory from the books of others [Galenic and Arabic texts] or place what has been described before their eyes; and the for-

mer are so unskilled in languages that they are unable to describe to the spectators what they have dissected.

How different from the Vincian vision was a scene like this.

The word *vision* is chosen advisedly, because it is direct vision that differentiates Leonardo's studies from all that fell under the heading of Galenic. In order to answer his perennial question of *why*, he had first to understand *how*, which demanded a meticulous attention to accurate anatomic detail such as had never before been so much as considered by any predecessor. To see clearly, to interpret objectively—these were the keys to solving nature's riddles. His was the artist's eye, but his also was the scientist's curiosity and the scientist's apperception that only by reducing a phenomenon to its component elements can it be fully understood. And only by knowing the minute particulars of structure can function even begin to be elucidated.

Long before Galen appropriated their writings to suit his own ends, the Hippocratic physicians of the fourth and third centuries B.C.E. had known this. Their observations of sick people were so detailed, and their written descriptions so accurate, that they could be verified by any person who would only take the pains to look with sufficient care. But because Hippocrates and his followers never studied anatomy there was no tradition of applying the same inquiring eye to the internal organs of the body as they had done with the exterior signs and symptoms of their pa-

tients. When Galen came on the scene half a millennium later, he relied on animal dissections and the speculative vision of the philosopher to help him elucidate anatomy and function when he should have been gazing intently at every human organ and every movement. And then, after a lapse of so many centuries, appeared Leonardo, a man who would once again recognize that the key to comprehending nature—and especially the nature of his fellow man—is first to see it with a vision so perceptive that no detail escapes scrutiny.

But it was not enough merely to see. What was seen had to be recorded, not only to preserve the newly acquired knowledge but to study it at leisure, especially in that era when there was no way to prevent the dissected structures from putrefying within days or even hours of the time they were examined. To Leonardo, it did not suffice, nor was it even recommended, that the recording be done by means of words, for only a picture can convey the reality of what has been scrutinized.

Oh Writer! With what words will you describe the entire configuration with the perfection that the illustration here gives? This, not having knowledge, you describe confusedly and allow little information of the true form of the things, deceiving yourself in believing that you can satisfy the reader in speaking of the configuration of any corporeal object, bounded by surfaces. But I remind you not to involve yourself in words, un-

less you are speaking to the blind, or if, however, you wish to demonstrate by words to the ears and not to the eyes of men, speak of substantial or natural things and do not meddle with things pertaining to the eyes by making them enter by the ears, for you will be very far surpassed by the work of the painter. With what words will you describe the heart without filling a book, and the more you write at length, minutely, the more you will confuse the mind of the reader.

Leonardo was more than as good as his word—he was as good as his picture. The writing accompanying the drawings in his anatomical manuscripts is by far secondary to the drawings themselves, as though afterthoughts or additions. They consist of explanatory comments, suggestions to himself for possible further illustrations, and statements of problems requiring further study. In fact, the anatomical manuscripts are primarily collections of drawings. The various drawings are in various states of completion, ranging from the superficial to the elaborately realized, with every possible gradation between.

And they are presented in a refreshingly new way. Leonardo was not content simply to show a structure as it appeared when seen from the front. He drew it from several other perspectives as well: back, side, bottom, top, and angles—whatever seemed necessary to make its three-dimensional nature clear. As noted earlier, he introduced the method of cross section, dividing a leg, for example, at mid-calf and showing what the open ends look like, in or-

der to demonstrate the muscles at that level. To achieve his purpose, he would dissect an organ or a limb several times using separate specimens, so that no detail of its anatomy escaped him. Sometimes he would show the depths of a body part in superimposed layers, like a transparency; sometimes he would show the depths by omitting the more superficial layers. To draw blood vessels, he might remove all tissues surrounding them, in order that they might be visualized in isolation.

These were not the only innovations. Bones were sawed through, to demonstrate their internal structure; the abdominal and thoracic viscera were drawn from behind, showing what they look like with the muscles of the back removed; wax was injected into hollow spaces within organs, like the ventricles of the heart and of the brain, providing accurate casts of their shapes. In dissecting the eye, a notoriously difficult organ to cut, Leonardo hit upon the idea of first immersing it in egg white and then boiling the whole, so as to create a firm coagulum before cutting into the tissues. Similar imbedding techniques are routinely used today, to enable accurate slicing of fragile structures.

Always, the intent was not only to show each part of the body as it actually is, but to demonstrate how it functions in the activity of the entire organism. In such a scheme, the three-dimensional relationships between various structures thus take on immense importance, as does the geometric arrangement of parts in a way that demonstrates the alignment of the forces that Leonardo recog-

nized to be so important to all movement. To study such forces, he would use copper wires to replace individual muscles on a skeleton, attaching them, for example, at the biceps's points of origin and insertion, so that the lines of contraction or relaxation would become evident.

If the words *had never been done before* were to appear as many times as they are justified in enumerating the anatomical attainments of Leonardo da Vinci, readers would soon grow tired of them and skeptical of their truth—and yet, there is no other way to put it, nor can it be sufficiently reiterated. Again and again, Leonardo was the first. What an incalculable loss, therefore, that no one knew what he had done, that everything had to be repeated decades or centuries later. The world of science had to wait for Andreas Vesalius to revolutionize the study of the human body, but only because the greatest anatomist who had ever lived kept counsel only with himself and the few others who never fully comprehended the immensity of his discoveries.

When he first took up his studies of anatomy, Leonardo did it as a painter might, to improve his understanding of form and expression, to paint "man and the intention of his soul," as he put it. But his insatiable curiosity got the better of him. Gradually, he became intrigued by what he was learning, and by how much more there was to know. He began bit by bit to fall under the spell with which the human body has entranced witnesses of its wonders since some unremembered primitive man

first stood transfixed over the slashed-open abdomen or chest of a dying enemy, watching the final movements of the living things within. Indeed, it was the movement even more than the mere structure that Leonardo craved to know, and before long he set out on his long and ultimately unfinished journey toward its comprehension.

Leonardo was well equipped for that journey, and he knew what was needed to undertake it. Having warned any prospective dissector (by whom he meant himself) of the horrors one must overcome to work with cadavers (see page 26), he went on to describe the skills that are required for the task:

> And if this does not deter you, perhaps you lack the good art of draftsmanship, which is essential for such demonstrations, and if you have the skill in drawing, it may not be accompanied by a knowledge of perspective, and even if it is, you may lack the methods of geometrical demonstration, and the method of calculating the forces and strength of the muscles; or perhaps you lack patience, so that you will not be painstaking. Whether all these things were found in me or not, the hundred and twenty books composed by me will give the verdict, yes or no. In these I have been impeded neither by avarice nor negligence but only by time. Farewell.

Though the author of these words never did write his planned 120 books, there are other bits of evidence that he intended eventually to publish a treatise on the human

body, probably in that number of chapters. In this, he was "impeded neither by avarice nor negligence but only by time."

Leonardo was possessed of all the qualities he deemed necessary for one who would study the human body. Every one of them was essential if life was to be portrayed as it really exists, form as it really appears, and action as it really occurs. He pointed out that perspective is "a function of the eye" and determined to find out as much about that organ and its relationship to human behavior as he could. And there was yet another reason to study the eye, a reason fraught with Leonardo's conception of how one approaches the study of all things in the universe: A knowledge of the eye is the point of embarkation from which one journeys toward a knowledge of life. To be understood, a thing must first be seen as it really is.

Among Leonardo's earliest researches were studies of the eye's anatomy and the anatomy of the brain to which it sends its messages, studies of optics, and studies of the properties of light. At first, his only intent was to explain how distance and light affect the appearance of an object, but he soon began an investigation of the eye's anatomy and physiology. At that time, it was thought that vision was perceived within the lens, but he was able to satisfy himself that seeing is in fact the result of light being focused on the retina.

Other than this, though, Leonardo's studies of the eye were not particularly successful, very likely because these

researches took place so early in his career as an anatomist that he did not conduct them with the same proficiency that he would bring to his later experiments. Considering what was then known, some of his conjectures nevertheless seem not unreasonable. For example, as he drew the path of light, it quite obviously needed to be explained why people do not see upside down. His solution to this riddle was to postulate that a double inversion occurs, the first at the pupil and the second at the lens, resulting in an upright image. Although he would later discard this formulation, he never did find the reason for upright images—but who could possibly expect that it was findable around the turn of the sixteenth century? He did recognize that the area of distinct visual acuity must be a very small point (later shown to be the macula), but he erroneously located it on the head of the optic nerve, another error that deserves mention only in light of the extraordinary quality of some of his other leaps of perception.

Although many anatomical observations and drawings appear in the *Treatise on Painting*, Leonardo's more scientific studies of the body seem not to have begun until around 1487, during his long sojourn in Milan. The first pictures were primarily descriptive; their purpose was to elucidate form and perspective. A product of this period was a group of quite beautiful drawings of the skull, one of which carries the date April 2, 1489, the earliest of such notations. Several other drawings from about this time show the skull sectioned at various angles to demonstrate

the sinuses, the eye socket, and the opening through which the optic nerve passes. In typical fashion, the accompanying text is scant. The famous drawing of coitus (see page 157), with all of its errors, also dates from this period, probably 1493.

Leonardo's notes and drawings provide evidence of his reading of what were almost certainly Italian translations of at least Mondino and Avicenna, and perhaps several others of the redactors of Galen. The errors he makes in these first attempts at anatomy bear the stamp of their influence and also of his dissection of animals such as the frog, dog, pig, cow, horse, and monkey, he having as yet worked with little human material. O'Malley and Saunders believe that the only cadaver parts to which he had access during the Milan period were a single head and perhaps a thigh and leg. But these and his animal work were enough to have already allowed him to introduce the use of cross-sectional anatomy. And these were also enough so that even the errors that he was making while still a novice did not prevent him from accomplishing considerable advances over virtually everything that had come before.

Beginning in 1496, Leonardo increasingly reaped the benefit of his close friendship with the mathematician Luca Pacioli, who, it will be remembered, had come to Milan in that year. Consequently, over the following decade he seems to have gradually magnified his inclination to see the human body in terms of its mechanics and

even its geometry. He began to turn his attention less toward artistic considerations and more in the direction of attempting to explain the physiological processes by which the body performs its functions. By 1505, at the age of fifty-three, he was well into his detailed study of the dynamics of human physiology as elucidated by anatomy. If his investigations after that time were to be divided into categories, they would consist of five: the muscles and bones, the abdominal organs, the heart, the nervous system, and the developing fetus in utero.

Actually, the investigations of the nervous system had been well under way even as early as the first Milan period, stimulated, as it were, by Leonardo's fascination with the origins of movement. Although still too much influenced by such as Avicenna and Mondino, he traced the peripheral nerves backward from the muscles to their origins in the spinal cord. Not only that, he began his long acquaintance with the brachial plexus at this time, which he was to bring to a successful conclusion some twenty years later by dissecting that structure in the body of the very old man of whose sclerotic arteries he made such astute observations. At some time after 1505, he pointed out that the action of a muscle is partnered with a reciprocal, or opposite, action on the part of another nearby muscle, a physiological phenomenon that would not be recognized until early in the twentieth century when it was described by the Nobel-winning neurophysiologist Sir Charles Sherrington. Though he illustrated it with a drawing of the struc-

tures around the hip joint, it is clear that he appreciated its generalized nature.

In the category of peripheral nerves, Leonardo also observed that the laceration of an extremity—the hand, for instance—might result in loss of either sensation or motion, and sometimes both. Though he did not put it in such terms, he had clearly discovered that some nerves are sensory, some motor, and some both. This was essentially a rediscovery of an observation originally made by certain Alexandrian physicians in the fourth century B.C.E. and known to Galen, but not generally appreciated.

The studies of the brain have been alluded to. Like some of the ancients, Leonardo was convinced that the site of the soul—a notion in which he firmly believed— lies in the brain. This was one of those inescapable vestiges of an inherited worldview from which even a mind as untrammeled as Leonardo's could not free itself. But he also saw the brain in a very modern way, as being the ultimate command center for all the body's activities, continuous with the nerves going to the entire periphery. To designate the place where he believed all the senses meet, he used the well-worn term *sensorium commune*, the invented location where the seat of judgment had since the fourth century C.E. been said to reside. His dissections having convinced him—erroneously and under the remaining influence of his reading—that the nerves lead directly or indirectly to one of the cavities of the brain called ventricles

which he had demonstrated by the injection of wax, he organized this entire concept into a single package, the muscular action of which could be described with an analogy:

> The tendons with their muscles serve the nerves even as soldiers serve their leaders; and the nerves serve the sensorium commune, as the leaders their captain; and the sensorium commune serves the soul as the captain serves his lord. So therefore the articulation of the bones obeys the tendon, and the tendon the muscle, and the muscle the nerve, and the nerve the sensorium commune, and the sensorium commune is the seat of the soul, and the memory is its monitor, and the faculty of receiving impressions serves as its standard of reference.

He was also aware that certain actions of the extremities and other parts take place without the intervention of consciousness. He needed to explain what he called "how nerves sometimes work without the command of the soul," and he did this by invoking a certain autonomy that the "leaders" develop when they have become accustomed to directing the "soldiers" to perform some activity, without requiring the orders of the "captain."

> The official who on more than one occasion has carried out the commission given him by the mouth of his lord will then himself at the same time do something which does not proceed from the will of his lord. So one often sees how the fingers, after having with utmost

docility learnt things upon an instrument, as they are commanded by the judgment, will afterwards play them without the judgment accompanying.

Though Leonardo is here speaking of those many voluntary actions we automatically and without thought perform as a result of training, his remarks refer also to reflex actions of all kinds, whether conditioned or inborn. In describing the phenomenon of the reflex, he also described the sensory-motor reflex arc, including the fact that it is centered in the spinal cord without intervention by a higher center, or "captain."

And so, even in the midst of erroneous interpretations based on the old theoretics of medicine and the universally accepted role of soul or spirit in all things, Leonardo managed to make observations and bring forth concepts that were centuries ahead of contemporary thought. In the other of the four categories he investigated, he was far more free of the restraints inherited by the thinkers of his time, as we shall see in the next chapter.

The Anatomy:
Matters of the Heart and Other Matters

"WHAT MAN IS, what life is, what health is"—these were the questions that Leonardo posed to himself. They are the themes that run through all of his investigations of the human body, whether in their earliest stages as demonstrated in the *Treatise on Painting*, or in the definitive studies that began around 1487 and reached their highest degree of accuracy in the period between 1508 and 1515. And always, the path that led to the solution of the problem was his preoccupation with movement.

In laying out the plan for his proposed great work on anatomy, Leonardo wrote, "Arrange it so that the book of the elements of mechanics shall precede the demonstration of movement and force in Man and other animals, and by means of these you will be able to test all your propositions." With this in mind, he conceived of the bones in the arms and legs as levers, and the muscles as the means by which force was applied to them. His notebooks are filled with drawings based on this principle, and it underlay much of his extensive work in the two fields that modern anatomists call myology and osteology. In all investigations

his aim, implicit in the writings, is to understand and even enter the mind of nature so thoroughly that he might be the interpreter between nature and art. Perhaps that great secret of Leonardo's is precisely this: We may nowadays know a great deal more about nature's behavior than he did, but he knew its mind as we never will.

The muscle that fascinated Leonardo the most was one that Galen had denied was a muscle at all, the heart. To the ancient Greek monarch of medicine, the heart's behavior was so distinctive that the organ could be composed only of some kind of tissue unique to itself. For thirteen centuries, that proposition went unquestioned, until Leonardo not only disagreed but pointed out that this muscle, like all others, depends on activation and blood vessels in order to accomplish its function. "The heart is a vessel made of thick muscle, vivified and nourished by artery and vein as are other muscles," he wrote, and went on to dissect the coronary arteries, drawing them as they arise from the base of the aorta, that great hose of a vessel rising up out of the heart's left ventricle. He identified not only the coronary arteries but also the three small bulges, or outpouchings, at the origin of the aorta, one just above each of the three leaflets, or cusps, of the valve separating it from the left ventricle. Two hundred years later, this trio of little bulges would be given the name sinuses of Valsalva, for the Italian anatomist who "discovered" them in the early eighteenth century.

Another of Galen's givens that Leonardo discarded was the role of the heart in producing what had since pre-Hippocratic times been called the innate or animal heat of the body. Its source was thought to be a kind of spiritual energy originating in the left ventricle. To the mechanistic mind of Leonardo, such a nonmaterial explanation was untenable, and yet the notion of innate heat was one of those assumptions of the time beyond which he was somehow unable to move. Agreeing with contemporary teachings that the heat exists, and that it comes from within the heart, he nevertheless departed from Galenic dogma in asserting that it is due to the friction of blood swirling through the organ's valves and chambers. In support of this proposition, he pointed out that the heart beats faster when a patient has a fever. Uncharacteristically putting the cart before the horse, he claimed that the greater number of contractions must obviously increase the movement and friction, thereby accounting for the elevated body temperature. We now know that body heat is the result of the energy produced by the thousands of trillions of chemical reactions that go on within us every instant of our lives (regulated by a temperature center in the brain), but Leonardo could not have conceived of such a possibility, especially since the rudiments of what passed for chemistry were in those days little more than the experiments of the alchemists. Some technological advances were still so far in the future that even the furthest reach of man's imagina-

tion—the imagination of Leonardo da Vinci—could not have conceived of them.

Leonardo's disagreements with the Galenic cardiac formulations transmitted by Avicenna and Mondino hardly ended with matters of heat and musculature. The older authorities taught that the heart consists of two ventricles into which the blood returned from the body and from the lungs respectively. These were thought to be capped by small earlike appendages to accept any excess of the blood and inhaled air that was said to be contained in the system. Leonardo pointed out that the heart has not two but four chambers: a right and a left ventricle and a right and a left atrium (which he called the upper ventricles, or auricles) above them, which are receiving chambers for the returning blood. He also demonstrated the papillary muscles, bandlike structures within the lower ventricles from which thin strands called chordae tendinae (also his discovery) stretch upward to the leaflets of the valves and contribute to the control of their movement. Having discovered the auricles (or atria as they are now called), he said that their contraction drives the blood down into the ventricles, which is for the most part correct. But he also believed that the ventricles in turn throw blood back upward before closing shut, and the resultant profusion of currents heats up the swirling liquid before it is distributed to the body by the arteries and veins.

In considering the fate of that distribution, Leonardo accepted the Galenic doctrine that the blood moved to the

periphery through both arteries and veins, and once having gotten there it was used up by the tissues for their nourishment, necessitating constant replenishment. Therefore still in some ways a man of his time, he entirely missed the concept of circulation which would be expounded by William Harvey in 1628.

One of the most well-known observations in the Vincian canon concerns the contraction of the ventricles. It was the custom in Tuscany to slaughter pigs by throwing them on their backs, tying them to a board and then driving a drill-like instrument through the chest wall and into the heart, so that they quickly bled to death. Since they died only after some number of heartbeats, Leonardo took advantage of the opportunity to study the external evidence of the motion of the ventricles. Taking careful note of the metronomic movements of the drill's protruding handle, he correctly concluded that the ventricle shortens during contraction, as would be expected of a muscle. Not only is there no record that this had ever before been detected, but Leonardo was also able to prove to his own satisfaction that the pulse simultaneously felt in the arteries is generated by that same ventricular contraction, an association not made by his contemporaries. He recognized that the pulse, the contraction of the ventricles, the thump of the heart's tip against the chest wall and the ejection of blood into the aorta are simultaneous events, a realization far beyond the teachings of his time, which saw no relationship between them. Interestingly, the method of study-

ing cardiac movement by driving a metal probe through the chest wall was reinvented in the late nineteenth century, and used as a remarkably accurate research tool by several eminent English and German cardiologists.

Of all Leonardo's insights into cardiac anatomy and physiology, there are two that are frankly astonishing. The first has to do with the function of the sinuses of Valsalva. Until at least the early part of the twentieth century, it was assumed by all cardiac researchers that the valve between the heart and the aorta (the aortic valve) functions passively, like that of a standard water pump: When the heart contracts, it pushes blood out and forces the valve open so that the blood can be ejected upward into the aorta; when the pressure of contraction lessens, the valve is forced shut by the weight of the column of blood in the aorta, pressing down from above it. This seemed a perfectly straightforward explanation of the hydraulics of the system, with the added virtue of simplicity, a trait long thought to characterize the artistry of nature.

But in 1912, it was demonstrated that the dynamics are not quite as simple as had been thought. In fact, the process of valve closure was shown to be somewhat more gradual than could be accounted for by an abrupt change in pressure relationships resulting in its snapping shut. And decades more had to pass before investigative technology had reached such an advanced state that the details could be satisfactorily explored and actually visualized. By the 1960s, dye and cineradiography methods had been suffi-

ciently developed that it was possible to study flow patterns with extreme accuracy. It was demonstrated that some of the blood which is ejected into the aorta swirls into the three bulging pouches lying just at its origin (the sinuses of Valsalva) and forms eddy currents that exert pressure on the upper surface of the valve, causing it to begin closing even before the ventricle has completed its contraction. This could not have been known without the new research methods.

Or so it was thought. Leonardo da Vinci had shown the same thing in the first decade of the sixteenth century. He began his experiment by creating a glass model of the aorta, complete with sinuses of Valsalva and also a valve taken from an ox or a pig. The model was inserted into the top of a water-filled beef heart, to reconstruct the anatomical situation as it exists in man. Leonardo describes the ingenious method he used in the absence of the X-ray techniques that would only become available almost 450 years later. "Let the water that strikes there have millet or fragments of papyrus mixed with it so that one can see the course of the water better from their movements." Both his text and illustrations clearly show the correct mechanism of both opening and closure of the three leaflets that make up the aortic valve, including the fact that the initiation of the closure is due to eddy currents originating in the sinuses of Valsalva. He demonstrated repeatedly that the closure is gradual. Leonardo's observations are identical with those that would be made by groups of researchers in a series of

studies beginning in 1969, and he drew the same conclusions from them as they would—all from watching the tiny bits of seed or paper swirl in the current of water. Of all the amazements that Leonardo left for the ages, this one would seem to be the most extraordinary. It is rendered no less so by the fact that he performed these experiments when he was more than sixty years old.

The second astonishing insight is more a matter of intuition than of experiment. Having dissected the body of the very old man who died suddenly, Leonardo fell to reflecting, as noted earlier, on the obstructed and tortuous arteries he found in the corpse. These findings were especially striking when compared with the smooth, wide-open vessels of the two-year-old child he anatomized at about the same time. He asked himself the question "Why [do] the vessels in the old acquire great length and those which used to be straight become bent, and the coat thickens so much as to close up and stop the movement of the blood, and from this arises the death of the old?" His answer is prescient, as his answers so often were: the vessel wall thickens, he suggested, as a result of absorbing an overabundance of nourishment from the blood—and this in an age when the notion of cholesterol and the whole panoply of ills later to be associated with overabundances in the standard Western diet had not so much as been guessed at. It was only in the second half of the twentieth century that researchers began focusing on the causes of arteriosclerosis,

and discovering that Leonardo had gotten it right 450 years earlier.

We cannot know whether Leonardo's statement that the heart is situated midway between the brain and the testicles was meant to have some kind of philosophical connotation. But it *is* certain that he mused long, hard, and often on the question of whether the heartbeat is automatic or whether it requires the activation of a nerve, perhaps the vagus which he had dissected all the way to its cardiac connections from its origin in the brain. At one point he said of the heart, "This beats of itself and never stops, except eternally," but at a later time he seems to have reconsidered, inserting a memorandum telling himself that he should study whether the stimulus comes through a nerve. Though he never did solve the problem, it is not surprising that its solution continued to elude researchers for centuries. It was not until the 1890s that a series of experiments by English investigators provided definitive evidence of what had by that time come to be called the myogenic theory, that the heartbeat is instigated by a mechanism inherent within the organ itself.

Leonardo's investigations of the heart were for the most part done during the period between 1508 and 1515, but his studies of the bones and muscles occupied him throughout the entire time that the notebooks were being written. They appear in the *Treatise on Painting* as well as in the Windsor Cas-

tle manuscripts. More than any other of his researches, the illustrations of these structures epitomize the approach he used toward all of his attempts to understand the body and its movement. As noted earlier, his aim was not only to draw each part from several perspectives, but to depict it sufficiently free of surrounding tissue that it might be seen in isolation. In other views, he left just enough of adjacent material to allow appreciation of relationships. In all cases, he would repeat his dissections as often as might be required to make drawings that provided a full comprehension of a structure's anatomy and function. Since cadavers and the opportunity to dissect them were not always as plentiful as he might have desired, he was limited by what was available. Because it was obviously easier to obtain an isolated arm or leg than an entire body, he was able to fulfill his criteria when studying the extremities far better than for any other regions. The following is a passage in which he preemptively responds to a doubter who might prefer watching an actual dissection to looking at the drawings. While reading it, Vesalius's description should be recalled, of how such procedures were done in the universities of the time:

> And if you say it is better to see an Anatomy performed than to see such pictures, you would speak rightly if it were possible to see all things that are shown in such pictures in a single body, in which with all your genius you will not see and will not have knowledge, unless it be of some few veins. Concerning which to have a true knowledge of them, I have [already] dissected more than

ten human bodies, destroying all other parts, consuming even to the minutest particles the flesh that surrounded these veins, without causing them to bleed, except for an insensible bleeding from the capillary veins.* And a single body did not suffice for so much time, so that it was necessary to proceed with as many bodies, one after the other, as would complete the entire knowledge; which I twice repeated in order to observe the variations.

Of course, for a man so intent on elucidating the mechanical principles involved in the functioning of the human body, there could be no more productive area of investigation than the bones and muscles. Basing his approach on the principle of the lever, Leonardo studied the body's movements as they are determined by the necessity for the maintenance of balance around its center. He analyzed the shifts of balance that occur in various forms of locomotion and at rest in different positions, and attempted to ascertain the lines of force involved in changing stability. He noted that the action of muscle groups acting reciprocally with antagonistic groups was an important factor in the maintenance of posture. As his scientific interests deepened, particularly after 1508, he focused on the mechanisms of movement of individual limbs and their parts.

To this end, a manuscript page or pages might show a

*Being microscopic, the vessels we nowadays call capillaries were unknown at the time. Leonardo was the first author to use the word, to refer to vessels so small that they cannot be seen by the naked eye.

drawing of a bone, followed by another of the same bone clothed by one or more of its muscles, and perhaps of its relationship to a joint to which it contributes. A tendon is then shown cut in such a way as to demonstrate what lies behind it, other muscles may be added, the extremity may move in any of its several actions, and the lines of force may be sketched in. The structure is seen from different angles and doing different things. The accompanying text is scanty and sometimes absent entirely. To Leonardo, the story is told in the picture.

Leonardo was particularly intrigued by the motion through which the hand supinates and pronates—turns its palm upward and downward. He found to his surprise that the biceps not only bends the elbow but helps turn the palm up by rotating the top of the smaller of the two fore-arm bones, the radius. He observed that the forearm shortens when the palm is turned downward, because the radius and ulna cross each other. In the course of studying the hand, he was the first to show its bones accurately, comparing them with those of the monkey and the wings of bats and birds. His interest in comparative anatomy is manifest also in drawings showing homologies between the lower limb of humans and the legs of the horse and the bear. Other firsts in the study of the skeleton were the demonstration of the double curvature of the spine, the tilt of the pelvis, and the correct number of vertebrae. In addition, Leonardo invented what is now called the "exploded view," in which the parts of a joint, such as the shoulder for ex-

ample, are drawn as though separated from one another, in order to demonstrate their relationships.

As groundbreaking as were Leonardo's studies of the heart and the musculoskeletal system, he was much less accurate a commentator on the digestive apparatus, although he was, in fact, the first observer to depict both the small and large intestines in their proper relationship with each other. By injecting melted wax into the vessels, he was able to make extremely accurate drawings of the arteries to the liver, bile passages, spleen, and stomach, as well as certain of the veins to these structures. He seems to have had a particular interest in sphincters, or *portinarii* ("gatekeepers"), as he called them, the anal sphincter most of all. Determined to elucidate the puzzling mechanism of anal contraction, he identified five muscles around the opening, which he believed to work in concert to close the canal and pucker its surrounding skin. Although he was wrong in the number of muscles and their dynamics, his basic concept was a correct one at a time when no one else had even thought of tackling such an abstruse problem. In any event, he was no further off the mark than were anatomists until near the middle of the twentieth century.

Because of the regard for life that would not permit him to vivisect animals—he was, in fact, a vegetarian for the same reason—Leonardo never observed peristalsis and seems to have had no knowledge of its existence. (There is one exception. Leonardo carried out an experiment in which he pithed a frog in order to study its response to stimuli when deprived

SHERWIN B. NULAND

of the neurological structures in its head.) Considering his fascination with movement, he would doubtless have had a great deal to say about the wavelike undulations by which the gut propels its sequentially processing cargo toward absorption of its contained nutriments until the eventual expulsion of the unusable residue. Being unable to account for the passage of digesting food down the intestinal tract, he attributed it to the propulsive force of intestinal gas and the action of the abdominal muscles and the diaphragm. Though he knew of the muscle layers in the gut wall, he thought their purpose was to prevent rupture when the gas pressure became high. To explain why material does not back up instead of continuing on its way rectumward, he invoked the natural bends, kinks, and turns of the small and large bowel, functioning like valves to prevent reverse flow. In his defense, it must be pointed out that dead intestinal tissues of a cadaver are prone to putrefy with particular rapidity, and this may be the reason that he was unable to study them with his usual meticulous care. Even the great Vincian must have had a threshold for the "natural repugnance" about which he warned would-be dissectors.

But Leonardo did accurately describe the act of swallowing and the passage of food as it bypasses the windpipe to enter the esophagus. And he made one other observation that had been missed by every one of his predecessors: He knew of the existence of the appendix, and drew it very clearly. Not surprisingly, for an organ whose reason for being is still largely a mystery, he was wrong about its func-

tion, conjecturing that it is a kind of cul-de-sac, capable of expanding to relieve gas pressure within the colon.

As for mysteries, there was none greater or more daunting in that century before the beginning of the scientific revolution than the mystery of conception and childbirth. Especially for a man who appears to have suppressed or repressed any overt expression of his sexuality—a man whose entire life may very well be explained as a continuous search for the idealized mother in whose love he had basked as a small child—especially for such a man, curiosity about every phase of reproduction, from concupiscence to cradle, must have been a powerful motivating factor.

Overtly, Leonardo proclaimed the disgust with which he viewed so much as the thought of coitus, using precisely the ambivalent language one might expect from someone with a smothered sexuality: "The act of procreation and the members employed therein are so repulsive, that were it not for the beauty of the faces and the adornment of the actors and the pent-up impulse, nature would lose the human species." And yet, he nevertheless was drawn toward what he seemingly found so repellent. He expressed his subdued drives in ways that a modern psychologist would not hesitate to call sublimation. In the case of the famed "coitus drawing," this conscious expression of consummated sexuality is, according to Kenneth Clark, so extreme that it "shows the strange detachment with which he regarded this central moment of an ordinary man's life." Many would agree, but others might just find something in this drawing that is so far from sub-

limation that it is frankly salacious, and even a bit reminiscent of the kind of sketch that giggling junior high school boys pass surreptitiously around the classroom. It is precisely this kind of contradiction that prevents any analysis of Leonardo da Vinci, including mine, to come any closer than approaching the boundaries of total conviction. No matter how apparently convincing the evidence of this or that hypothesis may seem, there is always a bit of evidence that stands in the way of certainty.

During his period of collaboration with Marcantonio della Torre, Leonardo had written that the great work he planned on anatomy would contain an all-inclusive description of every phase of the process of generation.

> This work must begin with the conception of man, and describe the nature of the womb and how the fetus lives in it, up to what stage it resides there, and in what way it quickens into life and feeds. Also its growth and what interval there is between one stage of growth and another. What it is that forces it out from the body of the mother, and for what reasons it sometimes comes out of the mother's womb before the due time. Then I will describe which are the members, which, after the boy is born, grow more than the others, and determine the proportions of a boy of one year. Then describe the fully grown man and woman, with their proportions, and the nature of their complexions, color, and physiognomy. Then how they are composed of veins, tendons, muscles and bones. . . . And three [perspective drawings] you

The coitus drawing.

must have for the woman, in which there is much that is mysterious by reason of the womb and the fetus.

This is more than a plan—it is a manifesto. In its bold declaration can be recognized the design for Leonardo's entire study of "what man is, what life is, what health is." And also in its bold declaration can be recognized certain problems with which reproductive researchers still struggle today, the most elusive of which is "what it is that forces it out from the body of the mother." But even before he undertook to declare its ultimate aim, Leonardo had already begun his exploration in a variety of ways, as we know from the *Treatise on Painting* and other earlier writings.

One of the ways is expressed in that illustration which has come to be known as the coitus drawing, and several other sketches that are associated with it. At the time when their total of four manuscript pages came into being, Leonardo was still very much under the influence of the ancient theoretics of Aristotle and particularly Galen, as they were transmitted by Avicenna and Mondino. In fact, much of the picture is consistent with the formulations expressed in Plato's *Timaeus.* The many errors of conception (pun unavoidable) to be found in the pictorial representations are traceable to those sources. Kenneth Keele says of the coitus drawing, "This, one of the best known of Leonardo's drawings, is also one of his worst anatomically."

The drawing itself probably dates from around 1497 and was therefore done before Leonardo embarked on the

detailed studies that would characterize his later work. It is a side view through the bodies of a couple in the act of sexual congress, the man's penis in the earlier sketches penetrating so far into his partner that it enters her womb, although it merely presses against the cervix in the ultimate version. Two canals pass through the tumescent organ, one for urine and the other connected to a source in the spinal cord, in keeping with contemporary (and ancient) belief that sperm is produced there and in the blood. The latter origin is demonstrated in the picture by a vessel passing from the heart directly to the testicle. The womb appears to be segmented in keeping with the Greek formulation that it had seven chambers, a notion that Leonardo later recognized to be false. A feature much remarked upon by historians of embryology is the depiction of a blood vessel connecting the womb to the nipple. At this early time in his studies, Leonardo still accepted the old doctrine that retained menstrual blood, not being discharged during pregnancy and the period of nursing, ascends to become the milk with which the fetus is nourished.

In contrast with contemporary theory that attributed penile erection to the pressure of air within the substance of the organ, Leonardo knew better, based on his observations of men hanged and reasoning from the color of the tip when aroused: "Of the virile member when it is hard, it is thick and long, dense and heavy, and when it is limp, it is thin, short and soft—that is, limp and weak. This should not be adjudged as due to the addition of flesh or wind, but

to arterial blood. . . . And again one observes that a rigid penis has a red head which is a sign of abundance of blood, and when it is not rigid, it has a whitish appearance." The ability of the erect organ to penetrate against resistance, he believed, was due to its position against the man's pubic bone. Thus, "If this bone did not exist, the penis in meeting resistance would turn backward and would often enter more into the body of the operator than that of the operated."

Leonardo's contemplations on the penis are of interest not least of all for their comments on the desirability of exposing it to public view, which seem in marked contrast to the revulsion expressed in the outburst quoted above:

> About the penis: This confers with the human intelligence and sometimes has intelligence of itself, and although the will of the man desires to stimulate it, it remains obstinate and takes its own course, and moving sometimes of itself without license or thought by the man, whether he be sleeping or waking, it does what it desires. Often the man is asleep and it is awake, and many times the man is awake and it is asleep. Many times the man wishes it to practice and it does not wish to; many times it wishes to and the man forbids it. It seems, therefore, that this creature has often a life and intelligence separate from man and it would appear that the man is in the wrong in being ashamed to give it a name or exhibit it, seeking rather constantly to cover and conceal what he ought to adorn and display with ceremony as one who serves.

In other words, the proper attitude toward the penis is pride. It is difficult to escape the conclusion that revulsion is reserved for the genitalia of the female, hardly surprising in view of all that has been surmised about Leonardo's sexuality. But matters are never as simple as all that, particularly when one is attempting to make sense of the inner life of such a complex individual. Here attention might again be called to Pater's observation of Leonardo's ambivalence, expressed in his art as the "interfusion of the extremes of beauty and terror," and the way in which "the fascination of corruption penetrates in every touch its exquisitely finished beauty." There was no greater expression of ambivalence— of the extremes of attraction and repulsion—than the Vincian's intense drive to study anatomy and reproduction, especially under the conditions of the time.

In contrast to the crudeness of design that characterizes the coitus drawing, Leonardo's much later depiction of a five-month fetus in the womb is a thing of beauty, or, as a distinguished Oxford art historian recently called it, "a miracle of intense presentation." It stands as a masterwork of art, and considering the very little that was at the time understood of embryology, a masterwork of scientific perception as well. It was an extraordinary ability to dissect, to observe, and to interpret that enabled this extraordinary mind to realize that there is no direct communication between the maternal and fetal placental blood vessels. What a surprise it must have been to William Hunter when in 1784 he looked into the manuscripts that had for 150

years been sequestered in that locked chest and found himself gazing at drawings that showed precisely the placental vascular anatomy that he was then in the midst of proving for all time by his own experiments. And what a shock it must have been to realize that he had been preceded almost three centuries earlier by an "unlettered" artist who had spent not a day in medical training.

In addition to his formal education and the benefit of the discoveries that had been made in the intervening centuries, Hunter had another great advantage over the Vincian, namely, the easy availability of human subjects to study. Although toward the end of his life Leonardo almost certainly dissected a fetus, most of his understanding of embryology derives from dissections of the cow, sheep, and ox. He nevertheless displays a good understanding of the membranes surrounding the developing fetus and introduced the technique of showing their nature by drawings in which they are peeled away in successive layers.

In an era when most authorities believed that all inherited characteristics came from the father, while some thought they came from the mother (and both sides were inclined to believe that every individual exists preformed in the seed of one or the other parent), Leonardo unequivocally stated, "The mother's seed has an influence on the embryo equal to that of the father's." To support his contention that the testes and ovaries have a similar function and make similar contributions to the offspring, he demonstrated that they have a similar blood supply. So far

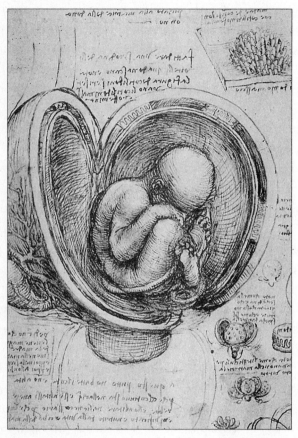

Leonardo's drawing of a five-month fetus
in the womb.

did he come from his original acceptance of the Greek formulation of a spinal origin of sperm cells that he in later years stated his correct conviction that the sperm created in the testes is passed into a holding area called the seminal vesicle where it is stored until needed for ejaculation; also, he showed how the ducts carrying the ejaculate enter the urethra. Another notion he discarded was that of the womb's seven chambers, his dissections having proven that it contains but one.

Leonardo was not content to make only qualitative observations of the developing animal fetus. As always, he made measurements when he could, determining the rate of the offspring's growth not only in the womb but after delivery as well. He was, in fact, the very first person to do such a thing, which would become a standard procedure only centuries later. It is for such determinations and the thoroughness of so many of his studies that the foremost historian of the field, Joseph Needham, calls Leonardo "the father of embryology regarded as an exact science."

In a biography where technical language is to be avoided and the luxury of length is absent, it is difficult to describe the magnitude and especially the depth of Leonardo's anatomical accomplishments. The quality of his dissections was unprecedented. So precise were they and so minute was his observation of detail that in this discipline—as in so many others to which he devoted his unparalleled talents—only a specialist can fully comprehend the range of his perceptions. Large volumes have been writ-

ten about Leonardo the anatomist and more will certainly appear in the future. But one comes away from perusing each one—regardless of its author's attempted detachment and determination to catalogue every instance in which Leonardo's ever-declining reliance on ancient authority led him into error—once more overwhelmed by the fact that such a man at such a time could have so well understood such a complex mechanism as the human body.

In the early part of the twentieth century, the Norwegian medical historian H. Hopstock summed up Leonardo's feats of anatomy with a completeness that no other of my sources has been able to achieve, not even O'Malley and Saunders or Kenneth Keele. In translation, he says the following in his 1921 monograph:

No one before him, so far as is known, made so many dissections on human bodies nor did any understand so well how to interpret the findings. His account of the uterus was far more accurate and intelligible than any that preceded him. He was the first to give a correct description of the human skeleton—of the thorax, the cranium and its various pneumatic cavities, of the bones of the extremities, of the vertebral column, of the correct position of the pelvis and the corresponding curvatures of the column. He was the first to give a correct picture of practically all the muscles of the human body.

No one before him had drawn the nerves and the blood-vessels even approximately as correctly as he, and in all probability he was the first to utilize dissections of a

solidifying mass in research on the blood vessels. Nobody before him knew and depicted the heart as Leonardo.

He was the first to make casts of the cerebral ventricles. He was the first who employed serial sections. No one before him, and hardly anyone since, has given such a marvelous description of the plastic surface anatomy, nor had anyone before him brought forward that wealth of anatomical details which he observed, nor given such correct information as regards topographical and comparative anatomy.

Hopstock might have added that no one, before or since, has "brought forward that wealth of anatomical detail" with more reverence for life than Leonardo, whether that life was human or animal. The universe, the earth, and every living thing fell into his purview, and he saw relationships between them all. Always in his studies one senses not only the will to know, but also the will that the knowledge will one day be of benefit to humankind. His reservations about dissection were answered by the certainty that it was for a higher purpose, and in that purpose he saw only good. Who is to know why Leonardo, who sought answers solely in things observed and knowable, should here choose to honor nature by honoring the Deity? He wrote:

> O searcher of this our machine, you must not regret that you impart knowledge through the death of a fellow creature; but rejoice that our Creator has bound the understanding to so perfect an instrument.

Bibliographical Note

NOT SURPRISINGLY, the very few readings "essential" for Leonardo seekers are not those filled with the greatest number of verifiable facts. They are instead three brief texts, each of whose authors sets a particular mood of his own in which to approach the Leonardo of legend. Giorgio Vasari (*Lives of the Most Eminent Painters, Sculptors and Architects,* abridged by G. duc DeVere, edited by R. N. Linscott [London: Medici Society, 1959]), Walter Pater (*The Renaissance: Studies in Art and Poetry* [London: Macmillan, 1917]), and Kenneth Clark (*Leonardo da Vinci: An Account of His Development as an Artist* [Cambridge, England: Cambridge University Press, 1952]), all of them men very much of their centuries, have perceived that the fullness of their subject cannot be imagined without steeping oneself in his aura, from which all interpretation may be said to follow.

After reading these three masters and passing the milestones they placed along the path of Leonardo studies, it is necessary to turn to the more mundane business of events, places, dates, and objective contributions. Here, too, there are three texts that can be highly recommended, two of which might be considered travelogues of their subject's life. In these books there is little interpretation of the Clark and Pater sort, but a richness of information and comment on events. The first is Edward McCurdy's frequently quoted *The*

Mind of Leonardo da Vinci (London: Jonathan Cape, 1928), which since its publication has served as a starting point for those who want to plunge directly into what was then known of the historic background of its subject's accomplishments. The other is Ivor Hart's *The World of Leonardo da Vinci* (London: MacDonald, 1961), a work focused primarily on the aspects of Leonardo's life that dealt with engineering and the realm of the mechanical.

The third of the recommended texts is *Leonardo da Vinci* (New York: Barnes and Noble, 1997), the perfectly huge (in both the intellectual and the physical sense) contribution of a large group of Italian scholars, each of whom has written on an aspect of Leonardo in which he is a specialist. Published originally by the Instituto Geografico de Agostini in 1938, the book was produced in conjunction with an exhibition in Milan of that year, meant to bring together all Leonardo scholarship, including reproductions of the machines, plans, and manuscript materials. The successful completion of the project was frustrated by the war, but it did result in this authoritative and quite magnificent volume of Vinciana as seen from every imaginable viewpoint. The book, a triumph of artistic publishing in its reproduction of the illustrations, was translated into English and reproduced first in the United States in 1956. One of its most valuable features is an extensive bibliography of pre-1938 sources, which modern readers might otherwise not have available.

A volume in much the same style was edited by Ladislao Reti under the provocative title *The Unknown Leonardo* (New York: McGraw-Hill, 1974). Reti brought together an international group of Leonardo scholars to explicate the contents of the Madrid Codices. The result was another of those great accomplishments of publishing in which a

learned tome is at once an intellectual adventure, a literary pleasure, and a feast for the eyes.

No year passes without the publication of several new biographies and commentaries on Leonardo. Over a hundred have appeared in the past decade and a half alone, more than a third of which are in English. Among the most thought-provoking and interesting are Richard Turner's *Inventing Leonardo* (Berkeley, CA: University of California Press, 1992), Serge Bramly's *Leonardo: The Artist and the Man* (New York: Penguin, 1994), and Roger Masters's quite unique *Fortune Is a River: Leonardo da Vinci and Niccolò Machiavelli's Magnificent Dream to Change the Course of Florentine History* (New York: Free Press, 1998).

Leonardo's own manuscripts were not systematically studied until the 1870s, and first began to appear in facsimile and transcription in 1881. The version that set the standard for those to follow in English was Jean Paul Richter's 1883 *The Literary Works of Leonardo da Vinci*, which has since then been reproduced many times, most recently in an excellent two-volume paperback by Dover Publications in 1970 under the more appropriate title *The Notebooks of Leonardo da Vinci*.

By far the best reproduction of any of the Leonardo writings is of the Windsor Castle anatomy collection prepared by Kenneth Keele and Carlo Pedretti, professor of art history at UCLA, for publication by Harcourt, Brace Jovanovich in 1979. This three-volume set, *Leonardo da Vinci: Corpus of the Anatomical Studies in the Collection of Her Majesty the Queen at Windsor Castle*, consists of two books of manuscript pages and a set of the drawings loosely contained in a box for ease of study.

Kenneth Keele's contribution to Leonardo studies is enormous, in the area of science and particularly anatomy. Of special importance are his *Leonardo da Vinci on the Movement*

of the Heart and Blood (London: Lippincott, 1952), his *Leonardo da Vinci and the Art of Science* (Hore, Sussex, England: Priory Press, 1977), and his *Leonardo da Vinci's Elements of the Science of Man* (New York: Academic Press, 1983). I have drawn freely from all of Dr. Keele's works, including numerous journal articles.

The present biography focuses on Leonardo's anatomical studies, an area in which a rich trove of treasures, large and small, is to be found. If one were to name a seminal work it would be J. Playfair McMurrich's *Leonardo da Vinci the Anatomist*, published by the Carnegie Institution in 1930. The other standards are *Leonardo da Vinci on the Human Body* (New York: Henry Schuman, 1952), by Charles O'Malley and J. B. de C. M. Saunders, and *Leonardo the Anatomist* (Lawrence, KS: University of Kansas Press, 1955), by Elmer Belt.

Two monographs, neither of which can be found by modern electronic methods, have influenced my thinking. Both are filled with keen insights, one on the man and the other on his anatomical studies. The first is "Leonardo da Vinci," the British Academy's Fourth Annual Lecture on a Mastermind, delivered on June 11, 1922, by C. J. Holmes, the director of the National Gallery. The second, entitled "Leonardo as Anatomist," is an essay published in Charles Singer's 1921 *Studies in the History and Method of Science* by a Norwegian identified only as H. Hopstock, now so unremembered that I could not find his first name, even with the use of computer searches. Whatever his first name was—perhaps Haakon or Hajo—Hopstock is only one among scores of scholars who have enlightened our understanding of the capabilities of the human mind, by studying a man whose name has become synonymous with Genius.